Hirschfeld's Hollywood

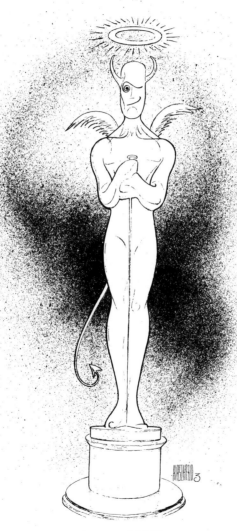

Oscar statuette ©AMPAS®

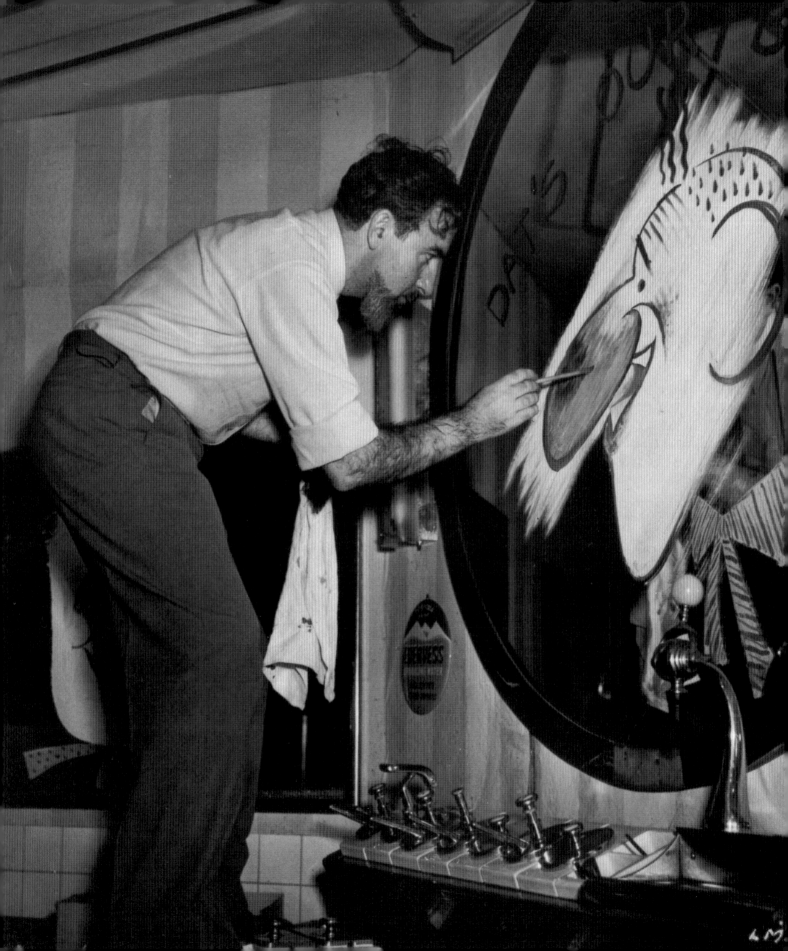

Hirschfeld's Hollywood

The Film Art of Al Hirschfeld

Text by David Leopold

Foreword by Larry Gelbart

Harry N. Abrams, Inc., Publishers,
in association with the Academy of Motion Picture Arts and Sciences

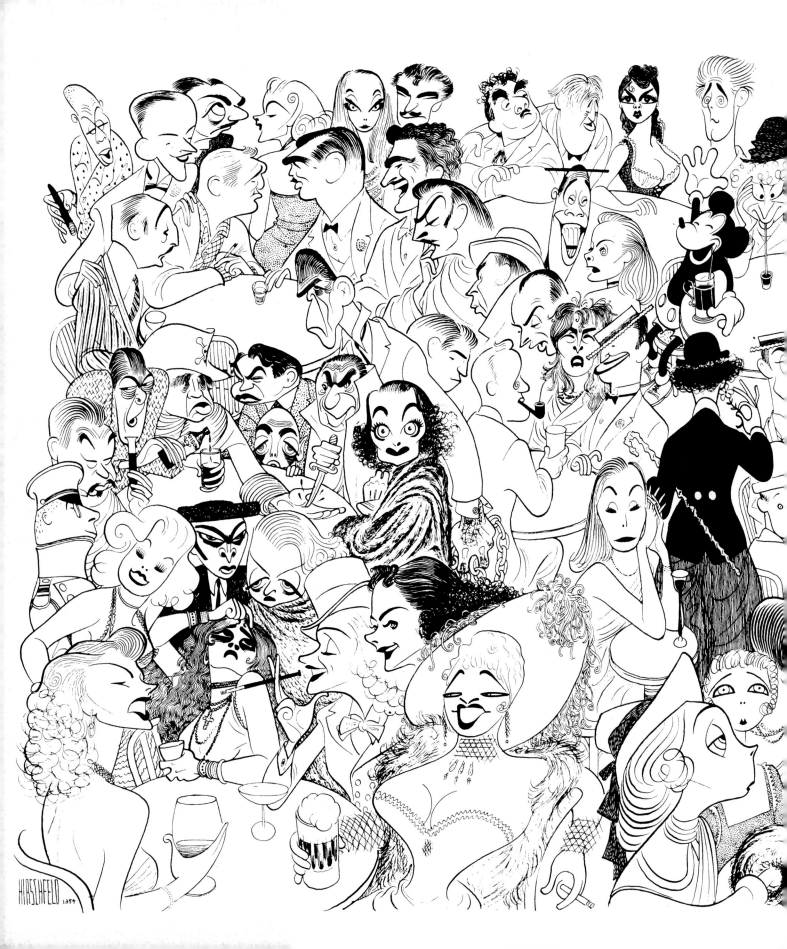

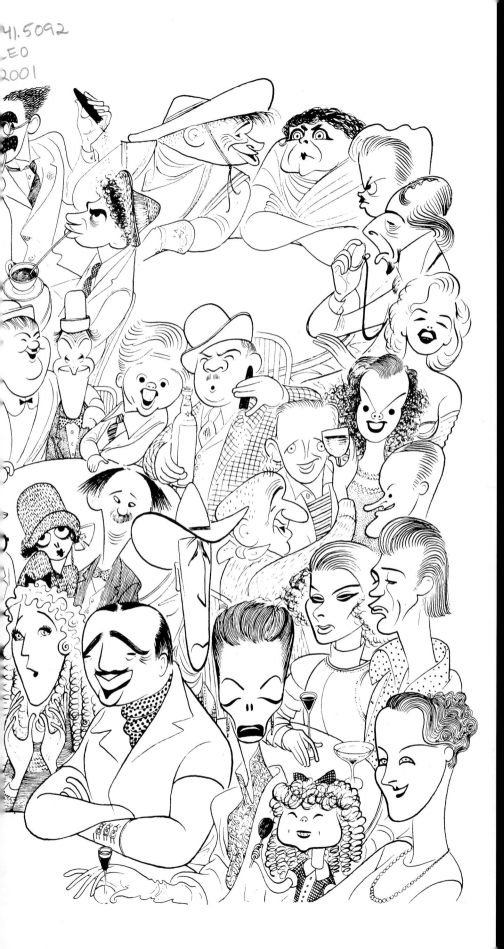

Contents

The Movies. Pen and ink on board, 1954. Whitney Museum of American Art, New York, Purchase, with funds from Mr. and Mrs. Samuel B. Brouner

Acknowledgments

Several years ago, Peter Levy brought me a poster for a film called *The Winning Ticket* and asked if the work could be by Hirschfeld. It was unsigned, of course, like almost all poster work, but there was something about it that made me think it was by the artist. Hirschfeld confirmed the hunch, and this project, in many ways, was born. In my subsequent conversations with Peter, and later with Woolsey Ackerman, I began to realize how much work Hirschfeld had created for film studios. Both Peter and Woolsey were instrumental in helping me organize the original material and they are the true unsung heroes of this project. I am grateful for their assistance.

I also appreciate that Robert Lantz recognized the importance of this material early on, and, with grace and good humor, encouraged me every step of the way. A low bow of thanks to Mike Glad who originally brought this material to the attention of the Academy of Motion Picture Arts and Sciences, which immediately responded with enthusiasm to the idea of this exhibition. Like so many other people, my only previous contact with the Academy had been through the annual telecasts of its awards ceremony, so it was a pleasure to work with so many of the people, from Executive Director Bruce Davis on down, who do so much more. I am thankful for Ric Robertson's support throughout the making of this book and exhibition. It is Ellen Harrington who I have seen, talked to, questioned, and collaborated with the most, and it has been a pleasure every step of the way. She brings an obvious joy to the job. Ellen is ably assisted by both Robert Smolkin and Jeni Cregan, who have been so helpful with myriad details. The staff at the Academy's library is, without question, the most capable group I have ever had the opportunity to work with. Every individual at the library was eager to share the riches in the collection with me, and I certainly would not have found many of the hidden treasures in the exhibition without their help. A special mention must be made of Anne Coco, the Academy's Graphic Arts Librarian, who spent countless hours with me tracking down assorted ephemera, and who oversaw the photography from the Academy. If there were more librarians like Anne, everyone would have a love of learning. Stacey Behlmer also helped me uncover a great deal of material, and always with a smile on her face.

Maxine Fleckner Ducey at the State Historical Society of Wisconsin helped me see some of Hirschfeld's earliest caricatures in Warner Bros. pressbooks, which gave me a clear understanding of how and when his style evolved. Mel Seiden's collection of Hirschfeld artwork at Harvard University, the best public collection of his work anywhere, was also a primary resource. For years, J. Geddis and Lynn Surry have been a sounding board for all things Hirschfeld. Their friendship and knowledge have meant a great deal to me. George Goodstadt has also been helpful in so many ways. I will never forget how Glenn Brown welcomed me into his home and family of friends on my initial foray in Hollywood.

Lisa Rathgeb and her crew, Brian Bourne, Jean Claude Marcel, Denise Goodman, Silvano Tanganelli, Jamie Cross, Linda Wern, and Chris Backert, are responsible for much of the photography in this book. I am the luckiest fellow in the world to have married Laura Rathgeb. Her reading, and rereading, of the manuscript has made it so much better. At Abrams, Ellen Nygaard Ford performed the alchemy known as design to make everything look wonderful. And I was fortunate to have as an editor Elisa Urbanelli, who turned the straw I provided into gold. Elisa's understanding, intelligence, and unflappable good humor have made everything so easy.

While all above deserve their top billing, the real stars of this production are Al Hirschfeld and his wife, Louise. Despite their star power, they could not have been nicer. Genius is something of a dirty word to Hirschfeld, and sentimentality may even be worse. Suffice to say, that in opening their home and, in many ways, their lives to me, I have been enriched beyond measure. Just keep those lunches coming!

David Leopold
April 2001

Al and Louise Hirschfeld wish to acknowledge the invaluable help of Robert Lantz.

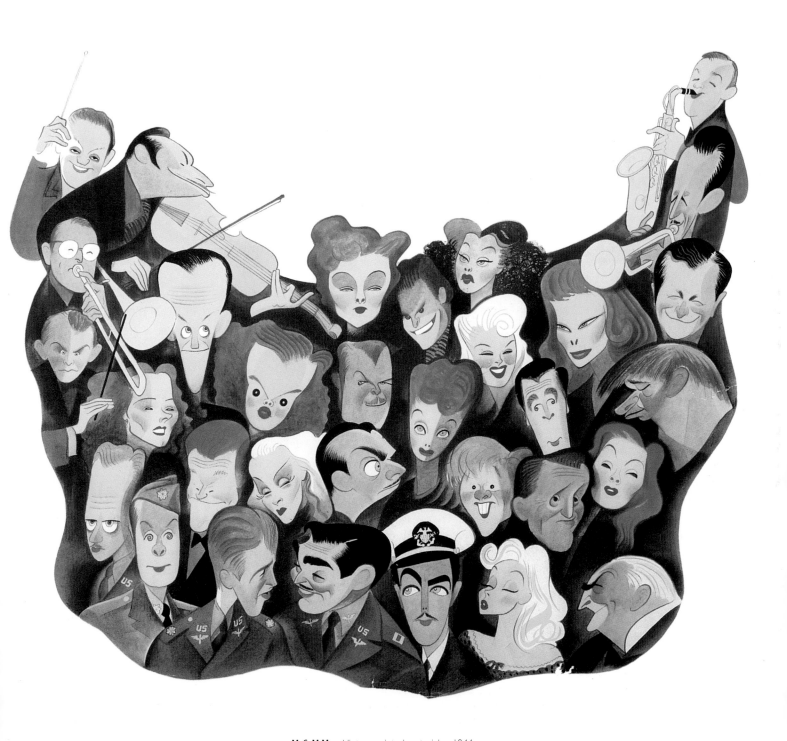

M-G-M Map. Vintage printed material, c. 1944

Foreword

In 1903, the same year that Al Hirschfeld drew his first breath, just a few minutes before he learned to draw his first line, the Russian physiologist, Ivan Pavlov, advanced his theory of learning by conditioning—training dogs to expect food whenever they heard a bell, eventually salivating each time the bell was rung.

Hirschfeld's Theory varies only in this way from the Pavlovian: Hirschfeld's followers have but to see his signature in the lower right-hand corner of a drawing, and their expectation of delight is automatically stimulated. Only unlike Pavlov's poor mutts, Hirschfeld fans always get what's been promised.

Whether on a poster, a marquee, a program, ad, or a postage stamp, Hirschfeld's unmistakable style triggers an automatic smile even before one takes in another example of his uncanny ability to externalize his inexhaustible energy and wit. (Is it mere coincidence that his initials represent the sound made to register satisfaction? And that backwards, they are the verbal expression of laughter?)

From the first flicker of motion pictures, right up to the present day, Al Hirschfeld has been there, drawn that.

From Astaire to Zorina. From Dove to Hawks to Pidgeon to Crowe.

His is an altogether stunning, unrepeatable career, stretching as it does from the nickelodeon age to the age of Nicholson.

Adding one more layer of immortality to an astral subject can often be only a first draft as far as Hirschfeld is concerned. His study of Burt Lancaster's career reveals his ability to do seven different takes of the same actor in seven of his most famous roles—revealing the actor's versatility, and that of his portraitist, as well.

Others in Hirschfeld's constellation have been afforded similar career-long representations. Henry Fonda was treated to Hirschfeld's POV of him from *Blockade* in 1938 (so long ago, the business had only one Fonda to its name) until his last film, *On Golden Pond*, in 1981.

No one is below-the-line in a Hirschfeld drawing. As much loving detail is devoted to a prop or reflector as to a star or a director (often indistinguishable from one another). Sketching on paper possibly composed of chips from Sequoias that may have been mere saplings when he began his career, Hirschfeld evokes crew members and extras who stand, sit, or loll in typical, recognizable attitudes. He shows us the ordinary in a completely different, far more detailed fashion. No aspect of filmmaking escapes his notice. Or his interest. Or his affection. Nothing is beyond his capacity to interpret—his hand forever able to execute what his eye records and what his heart reveals.

The motion in his pictures devoted to motion pictures is rightly legendary. His drawing for *The Miracle Worker,* in which he depicted Anne Bancroft, as Annie Sullivan, physically forcing Patty Duke, as the wild young Helen Keller, into submission, is a study in intensity and violence. As food, utensils, and furniture fly, it is very much as though Hirschfeld has let us sit in on the dailies.

Then there are the occasional comic throwaways, Hirschfeld's extra little bonuses for the insatiable. In his art work for *The Alamo,* Hirschfeld's signature is knocked sideways by the dust kicked up by the horses ridden by John Wayne, Laurence Harvey, and Richard Widmark. As with so many of his

drawings, the more you study it, the more it comes to life. There is real fire in the eyes of those horses; their flanks definitely ripple under their hides. The more you begin to hear their thundering hooves, the more you hope that the artist's signature will not be blown off the page.

Hirschfeld's humor, established almost from day one of his career as a sit-down comic, remains a constant in his work. Having once stated that early film comedians were his favorites (possibly because they came pre-caricaturized?), there is a direct line between the ones he used to draw Charlie and Buster, and those he uses to give us his woeful Woody.

And, of course, inevitably, there is NINA—an irresistible choice of child's name for Hirschfeld, given its heavy line quotient. Did any loving father, ever, ever send any daughter quite so many valentines? Ever show her how he could not help sharing his affection for her with all the world?

Nina, Nina, Nina, endlessly playing hide and seek—inside a curl, or a coif, or a tress. Nina, disguised as a wrinkle, Nina, as a crease. Fringe, feathers, furs, flames—there is not an object in this world that is safe from Ninafication.

As to Mr. Hirschfeld's longevity: it is no doubt safe to say that God, too, is a fan. (And, of course, He and/or She has no trouble at all, finding that fourth or fifth, that always elusive, last Nina.)

On a personal note, I am thankful to whatever Higher Agency is responsible for the dispersal of talent, for giving me not one whit of drawing ability. I can only imagine what a hellish life I would have led, how consumed by envy I would have been at the thought of Hirschfeld's 1,720,000 minutes of fame (based on the fact that he went to work at Universal in 1921—for the then-grand sum of seventy-five dollars a week—or just about what it costs to take a family of five to a movie today).

In the year that Al Hirschfeld came into a world he was to conquer with a pen mightier, more masterful, and filled with far more mischief than any sword imaginable, Antoni Gaudí, the Spanish architect, began building the upper transept of the church of the Sagrada Familia in Barcelona. To this day, the work of Gaudí remains unfinished. Happily for all of us, the same is true of Hirschfeld's.

The sum of his efforts—thus far—his near hundred-year-old oeuvre—is a testament to his abiding appreciation of one art form, while creating another one altogether.

After all this time, with nary a competitor in sight—nor hindsight—Al Hirschfeld remains the master—the undisputed Chairman of the Drawing Board.

Larry Gelbart [8]

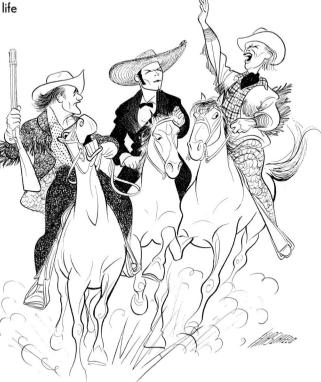

The Alamo. (with John Wayne, Laurence Harvey, and Richard Widmark). Pen and ink on board, 1960. Private collection

The Film Art of Al Hirschfeld

David Leopold

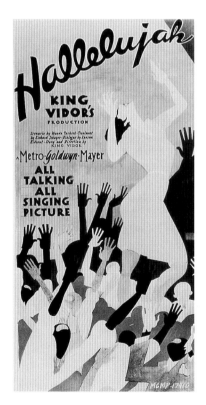

M-G-M studio portrait of Hirschfeld

Hallelujah! Vintage reproduction of
one-sheet poster, 1929

In the late 1920s, motion-picture studios made their films in an assembly-line fashion at a rate of almost one a week, and they sold their work much like manufacturing industries. Salesmen for each studio were dispatched to theater owners around the country, not with sample cases, but with fully illustrated books that described many of the studio's proposed offerings for the coming year, designed to convince an exhibitor to show the studio's output. The salesmen went out almost a year in advance of a film's release, and almost always before there was anything tangible to screen. The only representation of the film offered was the "flash" of the illustrator's conception of a film. At this point, the viability of the studio rested in the illustrator's hands.

A particularly effective example of these picture books was the *1929–1930 M-G-M Yearbook*. The book's illustrators, hired by the studios as part of their in-house art departments, were a diverse group that included Clayton Knight, William Crawford (who signed his worked "Galibrath"), Ted Ireland (whose pen name was "Vincentini"), John Held Jr., and a young Al Hirschfeld. They were given little more than a title, a general outline of the proposed story, and perhaps some idea of who might star in the film. Almost any of these factors might—and usually did—change. "There were few illustrators who could handle this type of work," says Hirschfeld of the art's specialized nature. "Who knew if the artwork had anything to do with the film they would eventually make? Or even if the film got made at all. The idea was to communicate the kind of film to the viewer, to make it interesting and exciting."

The artists populated the pages of this yearbook with images that conveyed the kind of film an exhibitor could expect. Responding to the broad clichés of the melodrama and physical comedy of these final silent films and early talkies, Hirschfeld produced a wide range of designs for the publication. For *Ordeal*, a ship-at-sea drama described as "the first important Talking picture with a sea-voyage as background," he created a sleek Art Deco–inspired design painted in the flat colors of a Japanese print. For his page on *Eva the Fifth,* "a play that just sits up and begs to be put into Talking pictures," he took a modern approach and broke his design into patterns of alternating colors, suggesting to the exhibitor outside of Manhattan the urban sophistication of the city where *Eva the Fifth* had been a hit on stage. Hirschfeld presented a chocolate brown dancer gyrating madly to the sounds of a multicolored jazz band for the first all-black "all talking, all singing" musical, *Hallelujah!*. (The image was later used as one of the three posters Hirschfeld contributed to the film's publicity campaign.) On the following page he painted a colorful border for a stirring testimonial to the film. It incorporates a variety of stereotypical images of good and evil drawn from African-American culture, from a fiery chariot to the hands of lost souls below.

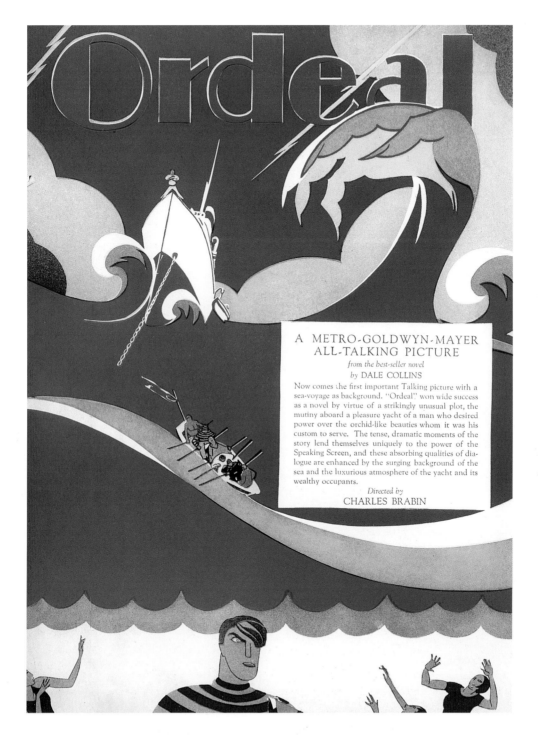

Ordeal

A METRO-GOLDWYN-MAYER
ALL-TALKING PICTURE

from the best-seller novel
by DALE COLLINS

Now comes the first important Talking picture with a
sea-voyage as background. "Ordeal" won wide success
as a novel by virtue of a strikingly unusual plot, the
mutiny aboard a pleasure yacht of a man who desired
power over the orchid-like beauties whom it was his
custom to serve. The tense, dramatic moments of the
story lend themselves uniquely to the power of the
Speaking Screen, and these absorbing qualities of dia-
logue are enhanced by the surging background of the
sea and the luxurious atmosphere of the yacht and its
wealthy occupants.

Directed by
CHARLES BRABIN

Ordeal. Illustration from the *1929–1930 M-G-M Yearbook*
*This film, based on a novel of the same name, was originally offered in 1928
and would be released in 1930 as* The Ship from Shanghai.

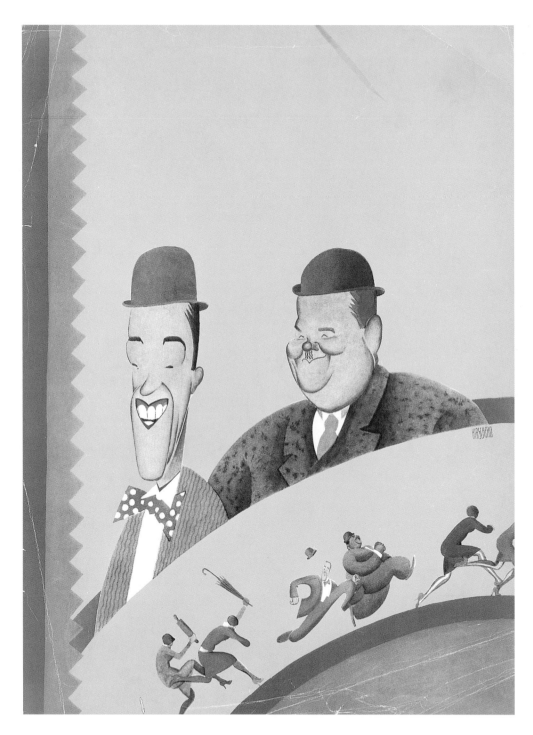

Laurel and Hardy. Illustration from the *1929–1930 M-G-M Yearbook*

The only caricature in the book—and the only work to bear his signature—is a page devoted to Laurel and Hardy's upcoming short films. Hirschfeld was among the first artists to turn the figures of Laurel and Hardy into easily identified graphic symbols. "To me, they always looked like the number ten," says the artist. This caricature, colored in vibrant hues, shows the duo smiling, while below is a scene of the two escaping from umbrella-wielding women in a circular format that suggests endless repetition. An orange sharp-toothed comb runs up the left margin, a refrain from many of his pages that gives the work a restless energy. These colorful pages, and others for the *1929-1930 Yearbook,* proved to be effective sales tools. Theaters around the country decided to take M-G-M's product, giving the studio its best year ever at the box office, a record that would hold until 1946.

In this post-dot.com moment, it is easy to understand how, in the flush of nearly a decade of economic speculation and expansion, movie studios in the 1920s sprang up virtually overnight, burned through their capital, and then disappeared in an industry shakeout where the remaining players were the result of the mergers of independents. Although film was a new medium, in the studios' infancy the old medium of print advertising was the only way to reach the public. Marketing departments, like today's software developers, flourished in a corporate structure that allowed for a wide degree of personal freedom. "Movie advertising was one of the few fields where you could do whatever the hell you wanted," remembers Hirschfeld. "Once you understood the

Laurel and Hardy wearing Hirschfeld-designed masks, c. 1933

Them Thar Hills.
Exploitation brochure, 1933
Tag lines, interviews, reviews, ads, poster designs, and ideas for local promotions were neatly gathered in a campaign book, also called an exploitation brochure.

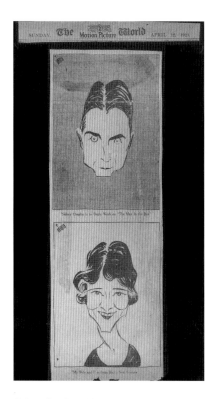

Sydney Chaplin in *The Man on the Box*; Irene Rich in *My Wife and I*. Published in the *World*, April 12, 1925

limitations of the Hays Code, you had all the freedom in the world. The Hays Code was insanity really. If I drew a couple kissing, they had to be more or less standing upright, and the man had to have a hat on. But there were no rules after that. Hal [Burrows] and Howard [Dietz] never objected to anything, no matter how crazy or abstract it was. It was different from magazine and newspaper work where you had to please the editor, the publisher, and the cleaning lady who knows exactly how the hand should be."

Hirschfeld had a handshake agreement with Hal Burrows, M-G-M's advertising art director, and Howard Dietz, M-G-M's publicity czar, who moonlighted as one of Broadway's most urbane lyricists, especially for the music of Arthur Schwartz. "They told me they were always making movies, so if I liked a subject or performer, I could do as many drawings as I wanted. I did not have to worry about the design of the poster, the lettering, and copy. They took care of that." There were ample spaces to fill for the one, three, six, twenty-four, and forty-eight-sheet posters that ranged in size from theater display cases to the sides of buildings. As a young man, Hirschfeld frequently was drawn to work on musicals and comedies: films with "the glandular actors," as the artist refers to them, the types that "don't close a door, they slam it. They're usually overactive thyroid cases with bulging eyes and blubber lips. Every gesture is big and sweeping, and they're great to draw." Marketing campaigns for films starring Charley Chase, Laurel and Hardy, Marie Dressler, and Wallace Beery were centered on his prodigious output.

This was not a job for the introspective, and many assignments were done in a day or two. "But it was a lot of fun to do," says Hirschfeld. "Johnnie [Held] loved to do it because he loved to go to movies. He didn't need the money. I did it because I had to pay the room rent, to make a living. But I was a great movie buff. I lived in the movies."

Dietz and Burrows at M-G-M recognized the appeal of caricature; as they wrote in a 1927 pressbook for *The Garden of Allah*, it was "a smart and novel method of publicizing pictures now very much in vogue, as a glance at any Sunday edition of the metropolitan papers will show." Caricature was the rage, and newspapers, magazines, book covers, and even cigarette cases were decorated in this stylized form of portraiture. Caricature of the 1920s venerated celebrity instead of destroying it. The era's caricatures were works of serious graphic composition, informed by a distinctly modern aesthetic and leavened by wit. While contemporaries such as Miguel Covarrubias, Al Frueh, Will Cotton, and Paulo Garreto published much of their work in "smart" magazines like *Vanity Fair* and *The New Yorker*, Hirschfeld's caricatures were much more democratic. They appeared on buildings, subways, and theater marquees, and landed in the hands of moviegoers in the form of heralds, programs, and other ephemera. His friends are credited with bringing caricature into the mainstream of graphic design, but Hirschfeld brought it to Main Street America.

Hirschfeld was a relative latecomer to caricature. His first published examples were of Irene Rich and Sydney Chaplin in the *New York World* on April 12, 1925. These rather crude caricature portraits for Warner Bros. films appeared a year and a half before his first theatrical drawing was published in December 1926. By then, he was a veteran of studio publicity and advertising departments, having already worked for Goldwyn, Universal, Pathé, Selznick, Fox, First National, and Warner Bros. Beginning in 1927, Hirschfeld would supply so much work to M-G-M that he became as closely associated with the studio in the 1930s and 1940s as he is with the *New York Times* today.

If he were at the start of his career today, Hirschfeld might gravitate to the action of Silicon Alley in Manhattan, but the emerging medium of his youth was film, and his first jobs were in studio advertising and publicity departments in 1920. As a teenager, he played semi-professional baseball on a team that included Lou Gehrig. In a chance encounter with another teammate on Fifth Avenue, Hirschfeld learned of work in the publicity department at Goldwyn Pictures. "My whole career," quipped Hirschfeld later, "began by walking on the wrong side of the street." Most studios were still based in New York at the time, and even after the gradual move to Hollywood, they kept advertising and publicity offices on both coasts. Having risen from errand boy to artist at Goldwyn Pictures almost overnight, he moved on to Universal before landing, in 1921, at the age of eighteen, as advertising art director at Selznick Pictures, a major studio of the period with a large advertising budget. He set up his own shop where the Museum of Modern Art stands today and hired a stable of artists to fill Lewis J. Selznick's needs before the company went bankrupt in 1924.

The traditional works Hirschfeld drew for these studios, which he now describes as "eye, ear, nose and throat specials," mirror the static quality of the early American cinema. Born in 1903, Hirschfeld is roughly the same age as motion pictures, and the evolution of his style reflects the maturation of the films themselves. His drawings are tentative at first, relying on the strength of their accurate description, and heavily influenced by the work of illustrator Charles Dana Gibson. Mass print reproduction was fairly crude by today's standards, and his simple representational drawings of performers and personalities such as actress Betty Compson, teenage David and Myron Selznick, and the newly appointed head of the Production Code office Will Hays, were the staples of newspaper promotion. His early paintings for posters and magazine advertising frequently reflect the finish of other reigning illustrators of the day, Cole Phillips and J. C. Leyendecker. For the premiere of Selznick's now lost and probably forgettable *One Week of Love*, Hirschfeld created what he calls "my Maxfield Parrish," showing Elaine Hammerstein and Conway Tearle against a

David O. Selznick. Vintage reproduction of 1922 drawing

David O. Selznick. Pen and ink on board. Published in the *New York Times*, November 15, 1992. Collection of Daniel M. Selznick

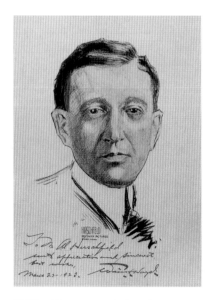

Will Hays. Vintage reproduction of 1922 drawing

purple mountain range. But as Hollywood films developed, the true kinetic quality of Hirschfeld's line began to echo the flickering of the image on the screen.

In the aftermath of the Selznick bankruptcy, at the age of twenty-one, Hirschfeld took a studio on West 42nd Street with Miguel Covarrubias and was bitten by the bug of caricature that Covarrubias had recently brought from his native Mexico. "There was something about Miguel's background that made him a natural graphic artist," Hirschfeld says, "and a lot of that rolled onto me." Covarrubias's stylized drawings and caricatures captured the zeitgeist of the 1920s and appeared in many top magazines. While Covarrubias's work was more accomplished than Hirschfeld's at the time, he would soon concentrate on becoming an anthropologist, set designer, and museum curator. It was Hirschfeld who would discover his own perspective and explore the graphic possibilities of line over a lifetime.

Hirschfeld's friendship with John Held Jr., who literally invented the look of the Jazz Age in his drawings, was just as crucial in the young artist's development. Held's thin line, derived from pre-Columbian sculpture and the drawings on Greek vases, as well as the highly stylized drawings in the profusely illustrated French weekly, *La Vie Parisienne*, was an important ingredient in Hirschfeld's early caricatures. They met in 1927 at the regular lunches that the M-G-M advertising art department staff convened at Barbetta's, a midtown restaurant. Despite his own popularity, before Hirschfeld left for one of his periodic trips to Paris, Held warned the young artist about the dangers of success and its attendant responsibilities: "Don't, for God's sake, ever earn more than you need to live on. Try not to be too successful."

After working a year and a half for Warner Bros. to pay off the debt he had accumulated in the demise of Selznick Pictures, Hirschfeld vowed never again to work for any one studio or publication, or to have anyone work for him. The resulting freedom can be seen in his sense of playfulness and openness to experimentation in the subsequent film work. Hirschfeld understood the function of his film art: to create visually compelling images that attracted attention in the briefest possible interval. He learned to purify the pictorial detail of his drawings and quickly gained a confident authority. The variety of graphic solutions employed—from the calligraphic ink drawing of *The Cossacks* (1927) to the animated collage of Laurel and Hardy in *Swiss Miss* (1934)—indicates a high degree of personal expression and genuine affection for films.

Hirschfeld's emerging style may be called distinctly American, since it was a melting pot of influences from around the world: the Mexican graphic approach of Covarrubias, the thin French line Hirschfeld discovered in Paris in 1925 and in the work of Held, the bold draftsmanship from the German journal *Simplicissimus*, and the elegant manipulation of values and perspective of Japanese woodcuts. Intuitively, Hirschfeld assimilated these influences into a personal style, his signature joyful, life-affirming line.

His sense of design was reinforced in a six-month visit to Moscow in 1928, where he witnessed the significant impact graphic arts had on Soviet society. Among his surviving drawings from this trip is a composite of eight portraits that appeared under the headline "Directing Minds of the Russian Cinema and Theater, Drawn from Life." Sergei Eisenstein is reduced to a figure eight, and Esther Schub to a helmet of black hair and eyebrows, using a pointillist technique to give detail and shading on both. Reproducing a subject's likeness has always been of secondary importance to Hirschfeld. "My primary interest is in producing a drawing capable of surviving the obvious fun of recognition or news value." When pressed, he now describes himself as a "characterist," but the focus of his early drawings was design, not character. He composed his full-page portraits of the top ten directors of 1928 almost completely from graphic symbols that leave a very stylish, if now dated, look on the page. In this American counterpart to his Russian drawing, Hirschfeld, influenced by Covarrubias's approach, gives each portrait a clean, geometric appearance and the feeling of a woodcut or linoleum cut through a manipulation of black and white contrasts.

Another international adventure, a ten-month stay on the island of Bali in 1932, would cement Hirschfeld's interest in the graphic possibilities of line. "It was in Bali that my attraction to drawing blossomed into an enduring love affair with line." He was enchanted by the dramatic shadows of Javanese puppets and the art of the island, and his sympathetic reaction to this environment

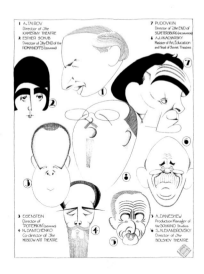

"Directing Minds of the Russian Cinema and Theater." Pen and ink on paper, 1928. Published in the *Herald Tribune*, November 28, 1928

John Held Jr. Pen and ink on board. Published in *Colliers*, April 1, 1955. National Portrait Gallery, Smithsonian Institution, Washington, D. C., Gift of the Estate of Mrs. John Held Jr. and Museum Purchase

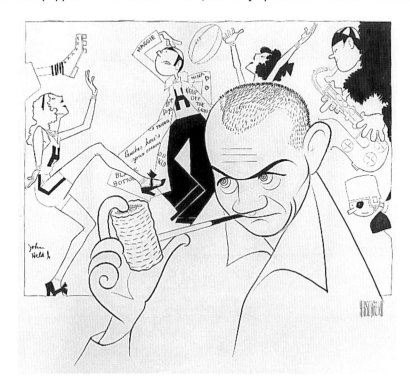

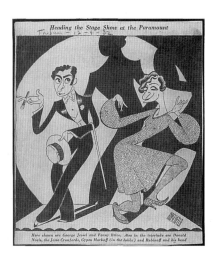

"Fanny Brice and George Jessel Heading the Stage Show at the Paramount." Published in the *Herald Tribune,* December 4, 1932

Parlor, Bedroom and Bath. Vintage reproduction of 24-sheet poster, 1931

instilled a belief that caricature expressed the magic of a child's world. When he returned to New York, the spotlight replaced the dramatic sunlight of Bali in Hirschfeld's pictures. In a drawing of the stage show between films at the Paramount Theater, he presents a shadow tableau of his own with George Jessel and Fanny Brice in poses similar to Balinese puppets. After Bali, he gave up easel painting altogether. It is no surprise then that a man who would later describe a picture of the Grand Canyon as a "diseased molar, dramatically lit," abandoned landscapes and focused on what interested him most: image in pure line.

Although the 1930s were a period of economic uncertainty, Hirschfeld was relatively secure financially because of the amount of work he was being assigned as an independent artist for a variety of studios and publications. Hirschfeld produced a stunning array of drawings in the decade, regularly capturing a steady stream of Broadway shows for at least three New York newspapers, in addition to his film work. Readers could often see different Hirschfeld drawings of the same production on any given Sunday in competing publications. Some of the theater illustrations are literary in their description of stage activity, decoration, and attention to detail. His film work, on the other hand, became simpler and more direct. This duality is due in part to context. The theater work appeared in newspapers, which provided the opportunity to include more visual information that could be read and lingered over. Film posters, seen at a distance, offered little opportunity to indulge in any details other than the most salient aspects of the figure or scene. In simplifying his compositions, he enriched and intensified the viewing experience, communicating volumes in a single stroke.

Hirschfeld defined the look of the Marx Brothers in posters for their first M-G-M film in 1935, *A Night at the Opera.* He knew his drawings had worked "when the Marx Brothers looked like my drawing rather than the other way around." There were many satiric portraits of the team before Hirschfeld's, but so complete was his rendition that all future drawings merely reinterpreted his. Even M-G-M's makeup department tried to get the Marx Brothers to conform to Hirschfeld's image of them. In *A Day at the Races,* their second M-G-M effort, Groucho's coiffure began to resemble the two triangles Hirschfeld gave him in his drawings.

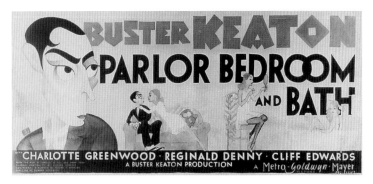

Eight weeks in Hollywood in 1942 provided Hirschfeld with an intimate view of the movie capital. For a *New York Times* article describing a visit with Charlie Chaplin, with whom he had become friends ten years earlier in Bali, Hirschfeld's description of the famous filmmaker and actor could easily be a description of the artist himself today: "White hair, honest blue eyes, a laugh more eloquent than any prose. Young in a way that few youths have ever been. Old with a rare dignity." In another illustrated piece for the *Times,* "On the Hollywood Front," he gently satirized the movie

colony's preparation for war, for instance, by showing how stars arrived by horse and buggy to premieres in order to save rubber, and first aid stations "where a broken fingernail, a lost eyelash or a torn stocking may be mended in a jiffy." In a third article for *American Mercury* magazine, he described the everyday insanities of life on Main Street Hollywood: "The true Hollywoodian is integral with his surroundings. He reflects in a wonderful way the strange life and the blown up values in the make-believe world he has invented and elaborated." The trip also changed his life in more personal ways. At the home of his friend, screenwriter Sam Raphelson, Hirschfeld learned that Dolly Haas, a German film star whom he had first seen in summer stock theater, had returned to New York after her divorce. He followed and married her one year later.

By the late 1940s the era of the illustrated poster ended, done in by the extensive billing demanded by agents and lawyers, as well as the public's growing appetite for photographs. Hirschfeld's commissions never slowed, but rather were redirected for use in newspapers and magazines across the country. Publicity departments recognized that Hirschfeld had an audience all his own, and that his work was often greeted enthusiastically by readers who were inured to traditional advertising. In his drawings, readers received a distinct point of view that made the tired formulas of some films seem like fresh concoctions. In addition, hiding his daughter's name, NINA, in his work had become the country's worst kept secret, and his drawings were pored over by some with the same relish as a crossword puzzle.

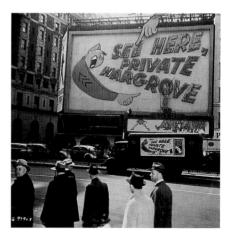

New York theater marquee for *See Here, Private Hargrove*, 1943

"On the Hollywood Front." On the set of *Sherlock Holmes* with William Post Jr. Ink and gouache on board. Published in the *New York Times Magazine*, August 23, 1942

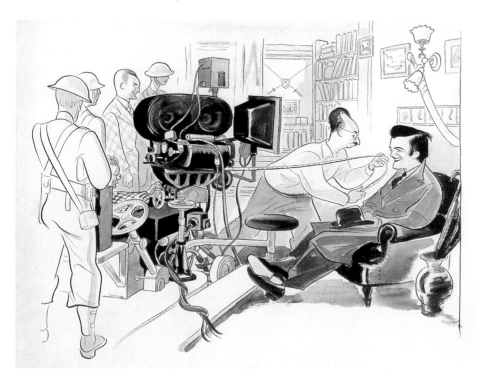

Elmer Gantry (with Burt Lancaster and Shirley Jones), 1960

As the studio system collapsed in the early 1950s, Hirschfeld continued to supply art for M-G-M films, capturing musical classics such as *Singin' in the Rain*, *Royal Wedding*, and *An American in Paris*, as well as the dramas *Quo Vadis*, *Ivanhoe*, and *The Great Caruso*. Crowded with more illustrative details than ever before, his film work occasionally echoed the expensive tastes of the studio. His theater work of that era, by contrast, reflected the renewed emphasis on simplicity in set design.

By 1957, Hirschfeld had again aligned himself with a leader in the industry, as United Artists made some of the most important films from Hollywood over the next decade, including *The Miracle Worker*, *The Defiant Ones*, *Paths of Glory*, *Judgment at Nuremberg*, and *The Manchurian Candidate*. Although for M-G-M he frequently drew musicals and comedies, he made a seamless transition to the "message" movies of the period. This relationship started slowly, with a poster of Charles Laughton in *Hobson's Choice* in 1954. The following year, he drew a cast headed by Katharine Hepburn in *Summertime*, before receiving regular assignments from United Artists over the next ten years. More than the change in genres, it was the style of acting that proved a challenge for Hirschfeld's pen. Gone were "exploded ventricles" such as Laurel and Hardy, Buster Keaton, the Barrymores, and Chaplin, whose larger-than-life personas "looked like their caricatures." Sounding like Norma Desmond in *Sunset Boulevard*, he said in an interview, "Performers have changed across the years. They used to be bigger than life; now they're smaller. The people on [screen] don't look any more theatrical than the people on the street." In his early days he drew Garbo, now he was drawing Gina Lollobrigida and Doris Day, who, despite pleasant looks, had less dramatic personalities. Where he once drew Clark Gable, he was now drawing Tony Franciosa.

Hirschfeld continued to enjoy his involvement with films and was occasionally asked to join a crew on location. Although a devoted worker, he is also a free spirit with a great sense of humor and a born raconteur, and thus was a pleasant addition to any shoot. In the summer of 1960, he traveled around the country by train visiting sets of UA pictures, filling an entire sketchbook with images from films in production. He went on location for *Inherit the Wind*, *Elmer Gantry*, and *The Alamo*, then returned home to fill the remaining pages with impressions of the filming of *West Side Story* and *The Apartment*, recording the scenes with the eye of a journalist on assignment. The slow pace of the actual filming allowed him to fill his sketchbook with numerous details of the production process, a luxury unavailable to Hirschfeld in the theater, where he sketched in the flurry of a performance. From the bag of cigarette butts on the set of Stanley Kramer's *Inherit the Wind*, to the ambulance for the maimed and injured on the set of John Wayne's epic *The Alamo*, he showed the nuts and bolts of production in drawings that presented news of upcoming releases.

The final film in the sketchbook was Billy Wilder's cynical comedy, *The Apartment*. Hirschfeld collated all of his sketches into a panoramic view of the location shooting on a New York street. Along with hiding a NINA on a storefront in the drawing, Hirschfeld also included the names of his colleagues at the *Times*, including Brooks Atkinson, Lewis Funke, and Arthur Gelb, in other store windows. This was a sly joke for his friends, who would undoubtedly have seen the drawing in one of the hundreds of publications in which it appeared.

Oddly, the *Times* resisted publishing any Hirschfeld drawings of films for years. When he inquired, he was told that motion pictures should be illustrated with photographs. It was not until 1965 that the *Times* featured a Hirschfeld drawing of the star-studded cast of *Ship of Fools*. Between 1965 and 1974, he contributed nearly sixty film drawings to the *Times* Arts and Leisure section. For interviews with movie personalities, he supplied portraits in line that distilled the essence of his subject, whether it be an anxious Elaine May or a heart-shaped portrait of Myrna Loy. To announce a film's opening or to accompany a review or article, Hirschfeld also drew scenes from films that were much more like his theater work, where the action of the moment is presented against the white of the board, allowing the viewer to concentrate on the movement.

The most complete document Hirschfeld has ever made of any production, whether film or theater, is his series of thirty-nine drawings for the film *Star!* The musical bio-pic of Gertrude Lawrence, starring Julie Andrews, was a lavish production, directed by Robert Wise and choreographed by Michael Kidd. Andrews was coming off the great success of both *The Sound of Music* and *Mary Poppins*, and 20th Century-Fox believed the movie was going to be a blockbuster. No expense was spared in its production, including a press kit in the shape of a show trunk filled with ersatz playbills, newspaper clippings, and announcements and copies of Hirschfeld's drawings. Hirschfeld captured all aspects of the film, from its production numbers to portraits of the performers and creative team, and even location drawings showing the filming of the epic picture. In addition to his work in the press kit, several of the drawings were reproduced in a special feature in the *Saturday Evening Post*. Unfortunately, the studio's faith in the film was not repaid at the box office, where the film did poorly.

In the 1970s and 1980s, while he continued to receive commissions from studios for publicity drawings and occasionally a poster, Hirschfeld had significantly less film work. The promotion of films had changed and there was greater reliance on television advertising and

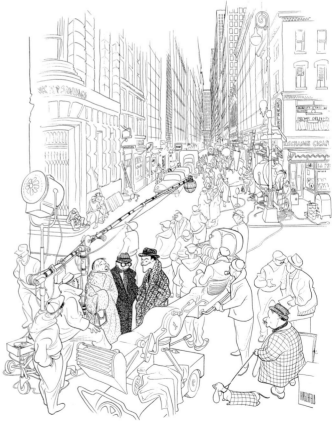

On the set of *The Apartment* (with Jack Lemmon, Shirley Maclaine, Billy Wilder, and production designer Alex Trauner), 1960

On the set of *Star!*, 1968

less on print media. Few remember titles such as *Honky Tonk Freeway*, *Rollercoaster*, *Seems Like Old Times*, and *Sphinx*, to which Hirschfeld lent his pen. However, with assignments for several of the era's classics—*Victor/Victoria*, *The King of Comedy*, *Arthur*, and *Tootsie*—Hirschfeld produced inspired drawings that succinctly captured the performers' own distillations of their characters. Increasingly, however, he was asked for images of the Golden Age of filmmaking. In 1977 IBM commissioned forty-eight drawings of film classics for a special television presentation. Although he had drawn several of the films when they were originally released, Hirschfeld took the opportunity to further refine what he had first created a generation earlier. For instance, when *Singin' in the Rain* was released in 1952, Hirschfeld produced a complicated drawing of Gene Kelly with an umbrella, dancing alongside Debbie Reynolds, while Donald O'Connor peeks out from the left border and a chorus line vamps behind them. In 1977 Hirschfeld eliminated everything but Kelly and the umbrella, instantly communicating the film to readers. Demand for prints of his work also brought commissions for images of a number of film personalities, both classic and contemporary: Marilyn Monroe in *The Seven Year Itch*, Paul Newman and Robert Redford in *Butch Cassidy and the Sundance Kid*, and Woody Allen and Diane Keaton in *Annie Hall*.

In the 1980s, Hirschfeld stopped his regular moviegoing to some extent. "I don't see any human beings anymore on the screen," he said in a 1987 interview. "They're all coming out in suits of armor with headdresses that light up. I remember one movie, *E.T.*, where the woman sitting next to me was weeping, she was so tremendously moved. I thought, 'My God, what's happened to me? I can't get involved with these pipe cleaners. Here's this little pipe cleaner jumping around and this woman is so upset because he's not feeling well.' I thought, 'I'm losing my mind!'"

Hirschfeld accepts the change as a part of life. "It's just different today. I accept the form the way it is, I don't demand that it be what it was. I don't think it's any better than it was, but I don't think it's any worse. . . . Times have changed. You become much more sophisticated. You look at an old movie and you suddenly see a shadow on a building. *The Cabinet of Dr. Caligari*, I remember that movie, I thought that was a great work of art. I was convinced that it was a thing that would last forever. I saw it at the Museum of Modern Art a couple of years ago, and it's a farce. The makeup, the black under the eyes! The fellow closes a door and all the buildings shake. I wasn't aware of that when I first saw it, it was all real to me." Hirschfeld may not "live in the movies" anymore, but he remains a devotee by watching a mix of old and new films each week at home and attending screenings of the latest work of his friends Woody Allen and Milos Forman, among others.

In the 1990s he returned to many of the personalities he drew in their first flush of fame. The United States Postal Service commissioned drawings for postage stamps of performers who had left an indelible mark on American culture. The first set of five stamps, "Comedians by Hirschfeld," was released in 1991 and featured concise portraits of Jack Benny, Fanny Brice, Edgar Bergen

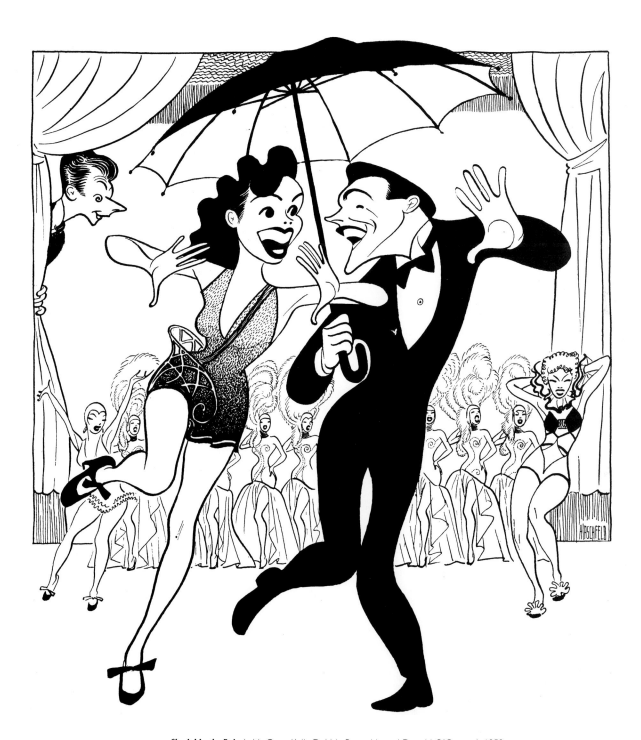

Singin' in the Rain (with Gene Kelly, Debbie Reynolds, and Donald O'Connor), 1952

"Mickey Mouse Can Be All Things to All Men." Published in the *New York Times Magazine*, December 26, 1937

Eric Goldberg. Pen and ink on board, 1995. Eric Goldberg Collection

and Charley McCarthy, Abbott and Costello, and Laurel and Hardy. More than sixty years after his first drawing of the team, Hirschfeld's rendering of Laurel and Hardy had become their government-sanctioned image. In 1994, a second set of ten stamps was issued, "Stars of the Silent Screen," which included Buster Keaton, Charlie Chaplin, Theda Bara, John Gilbert, Harold Lloyd, Clara Bow, Rudolph Valentino, Zasu Pitts, the Keystone Kops, and Lon Chaney. Seventy years after he first drew an "eye, ear, nose, and throat special" of David O. Selznick for Selznick Pictures, Hirschfeld was assigned to capture Selznick for a *New York Times* book review of the producer's biography. The two portraits fully illustrated the evolution of Hirschfeld's ability to convey character in an elegant line.

Hirschfeld also became a movie star in his own right. After making a cameo appearance in the 1953 film *Main Street to Broadway*, he played the lead in the 1996 Oscar-nominated documentary *The Line King: The Al Hirschfeld Story*, written and directed by Susan Dryfoos. Much like a Hirschfeld portrait, Dryfoos succinctly captured the artist's then ninety-three years of life in eighty-six minutes.

Hirschfeld's dynamic line, with its implied movement, continues to be a star in the realm of animation. "The animated cartoon started out as pure caricature. A line appeared and it drew itself into a figure whose belly button danced in wild abandon," wrote Hirschfeld. "The audience loved this pure art form." In the early years of animation, he felt that the medium held much promise. But he later felt that Walt Disney was corrupting the art with a much-too-literal approach. In reviews for the *New York Times* on the release of *Snow White* in 1938, and *Pinocchio* in 1940, Hirschfeld argued that trying to re-create reality in animation was self-defeating. "Snow White, with her full complement of fingers and fingernails, eyelashes, one-dimensional head, bare arms without solidity, and uninventive neck, is an awkward automation. These awkward symbols do not articulate, and the lovely voice with which she is endowed only heightens the effect of a ventriloquist's dummy."

Disney never heeded Hirschfeld's constructive criticism, but Disney animators have studied Hirschfeld's drawings for years for their ability to move and communicate. In 1994, animator Eric Goldberg based the madcap genie in *Aladdin* on Hirschfeld drawings. "Hirschfeld is great for the strength of his poses," said Goldberg in recognizing his debt to Hirschfeld. "They are very read-

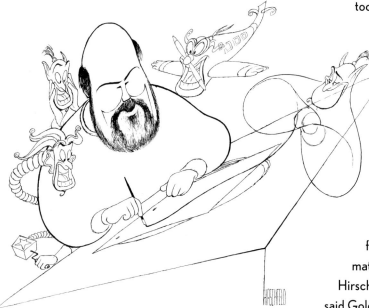

able from a long, long distance away. They have a great deal of elegance from one line leading organically to the next." When he visited the Disney studios after *Aladdin* was released, Hirschfeld marveled at the army of artists working on one project. "I have never known three artists who could work on anything without getting into a fight."

The Genie's ability to transform himself instantly into a number of personalities also made Hirschfeld a logical choice for emulation. And what better way to communicate star status than a Hirschfeld drawing? To many, having their portrait drawn by Hirschfeld is as great an honor as an Academy Award. "It used to be an insult," laughs Hirschfeld, "now it is an accolade." Today his portraits of Hollywood's players are significant totems of success in the film world on both coasts, for their rich design and consummate draftsmanship, as well as for their link to Hollywood history.

When Eric Goldberg and his wife Susan decided to make a short animated work based on a day in the life of Manhattan, they naturally thought of Hirschfeld. Hirschfeld suggested the music of George Gershwin's "Rhapsody in Blue." He was asked to create drawings for the piece but demurred, saying "It is a whole other career." Instead, the Goldbergs paid homage by basing the entire segment on Hirschfeld's style. This distinctive work was not released as a short, but was incorporated into Disney's feature film, *Fantasia 2000*.

Many of the studios that Hirschfeld supplied with drawings have prospered, peaked, and disappeared. Many of the stars he has drawn have passed into history. Publications have folded. But Hirschfeld's Hollywood has remained unchanged. As he wrote in 1943, it is a "make-believe world" whose "seeming insanities and inanities are really part and parcel of the search and adjustment which mark the emergence of a quite new art form." Eighty-one years after his first film drawings, Hirschfeld still sits in his barber's chair coaxing his unpredictable line onto his illustration board. Soon after the 2001 Oscar nominations were announced, the Sunday *New York Times* featured Hirschfeld's colorful composite portrait of the top nominees. In an ever-changing world, he has remained a constant, but not the same. "The longer I stay with line, the longer I can do what I want. I want to keep simplifying my graphic description of someone's character. Now I am down to a pencil, a pen, and a bottle of ink. I hope one day to eliminate even the pencil."

Dreamworks Team (with Jeffrey Katzenberg, Steven Spielberg, and David Geffen). Pen and ink on board. Published in the *New York Times*, October 16, 1994. Private collection

"If you live long enough," Hirschfeld is fond of saying, "everything happens." While the Times shunned Hirschfeld drawings of films for many years, they commissioned this work for the front page of the paper.

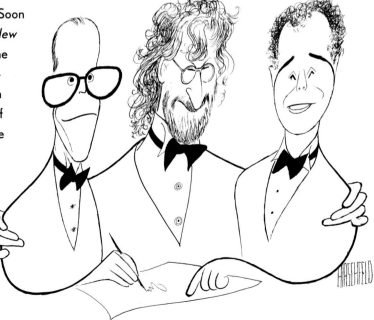

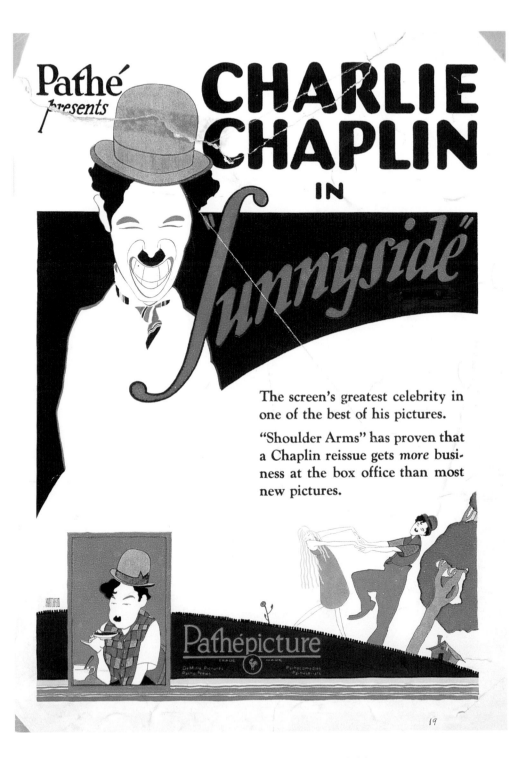

Sunnyside. Window card, 1924. For re-release of 1918 film

One of Hirschfeld's first caricatures was this window card featuring Charlie Chaplin. Hirschfeld has drawn this film icon more than twenty-five times, including a portrait for a United States postage stamp.

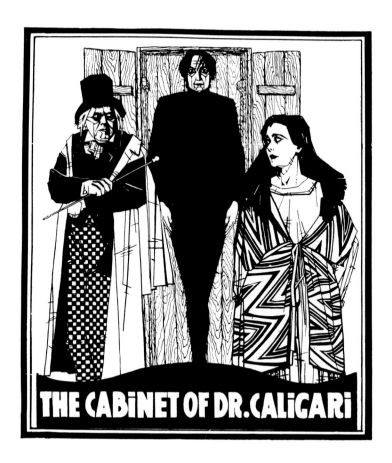

The Cabinet of Dr. Caligari.
Theater lobby display, c. 1921

Red Courage.
Newspaper advertisement, 1921

Learning of the art department at Goldwyn Pictures was Hirschfeld's first intimation that it was possible to earn a living drawing movie stars. Howard Dietz, then director of advertising at the studio, was the first to recognize his talent. When the office became overstaffed, Hirschfeld moved on to Universal, where he worked under Winhold Reiss.

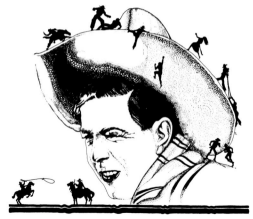

CARL LAEMMLE PRESENTS

HOOT GIBSON

IN PETER B. KYNES SMASH-BANG
STORY OF A YOUNG WESTERN
DARE-DEVIL WHO LAUGHED AS
HE FOUGHT A WHOLE TOWN.

"RED COURAGE"

DIRECTED BY REAVES EASON

A UNIVERSAL PICTURE

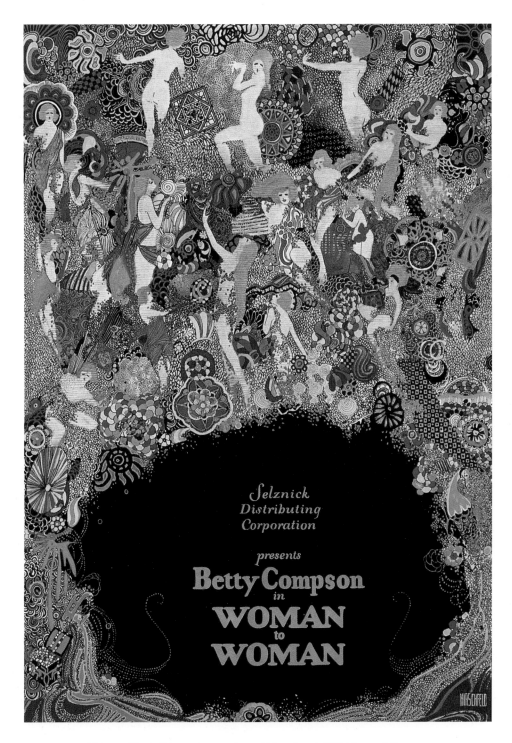

Woman to Woman. Watercolor, gouache, and ink on board, 1923. Library of Congress

As art director at Selznick Pictures, a substantial job since Selznick ran more ads than other studios, Hirschfeld created art in a wide variety of styles. Lewis J. Selznick, the company's founder, had "a wild talent for theater" according to Hirschfeld, but that did not stop the studio from going bankrupt soon after this film was released.

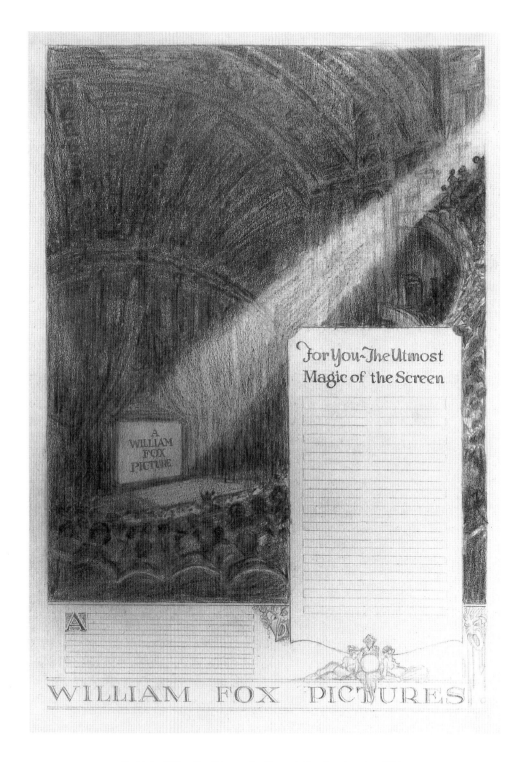

Sketch for William Fox Pictures advertisement. Pencil on board, c. 1926

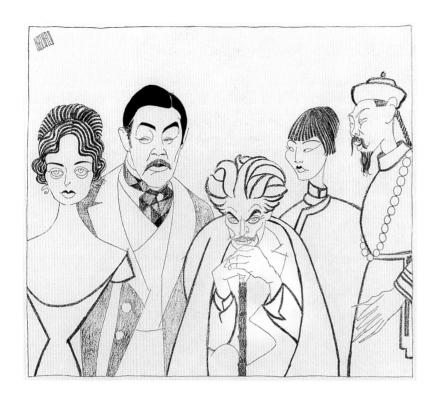

Old San Francisco (with Dolores Costello, Warner Oland, Josef Swickard, Anna May Wong, and Sojin); **Tillie the Toiler** (with George Fawcett, Marion Davies, George K. Arthur, and Matt Moore). Caricatures for pressbooks, 1927

While living in Paris, beginning in 1925, Hirschfeld returned to the United States every few months to "add to my collection of contemporary money," primarily with assignments from film studios. Hirschfeld employed an array of graphic textures and design in his work.

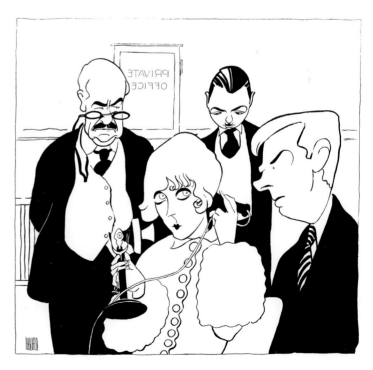

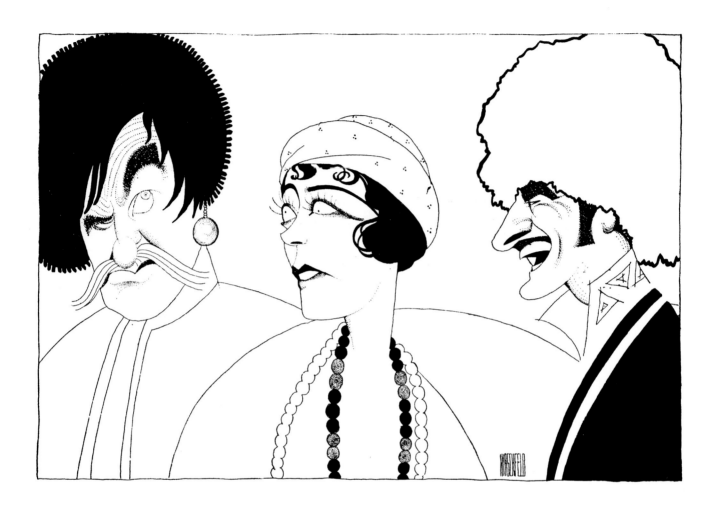

Cossacks (with Ernest Torrance, Renée Adorée, and John Gilbert). Caricature in pressbook, 1927

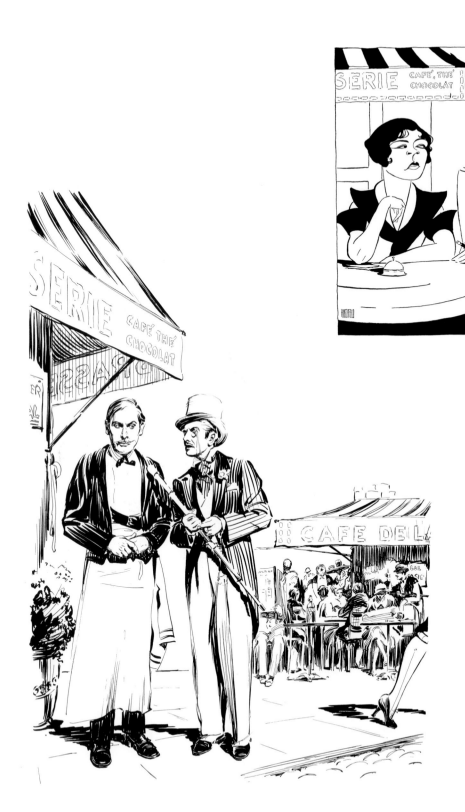

On Ze Boulevard (with Renée Adorée, Lew Cody, and Roy D'Arcy). Illustrations for pressbook, 1927

Hirschfeld pursued his interest in caricature in earnest while continuing to produce works in a more representational style, providing advertising campaigns with a range of work.

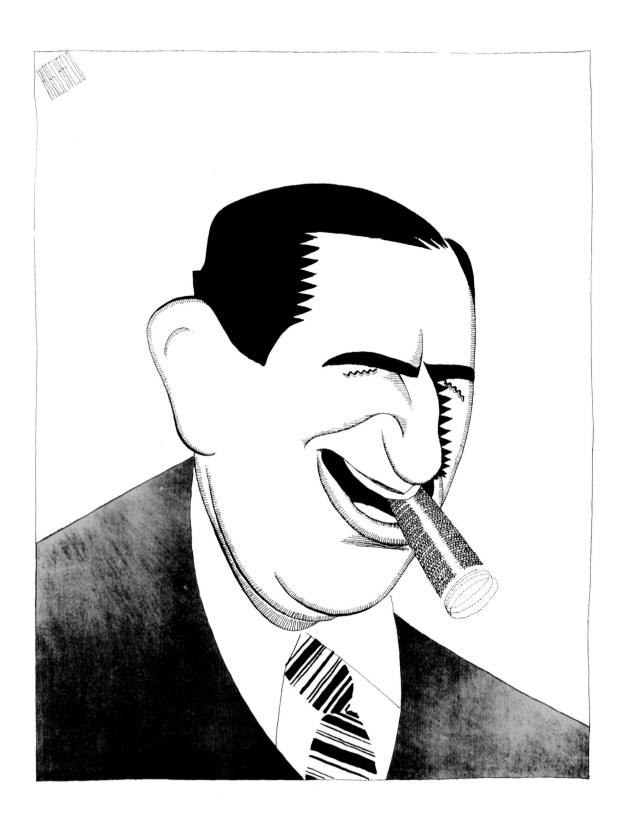

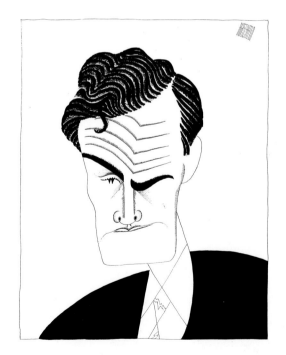

Opposite: **Ernst Lubitsch**

Clockwise from top left:
Cecil B. De Mille, Raoul Walsh, William Wellmann, F. W. Murnau.
Illustrations for *Film Daily's* 1929 *Directors' Annual & Production Guide*

These full-page portraits capture five of the ten top directors of 1928 as voted by the readers of Film Daily, *an industry publication.*

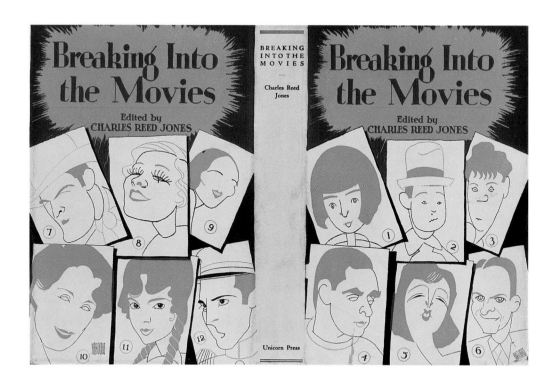

Breaking Into the Movies
(1. Colleen Moore 2. Harry Langdon
3. Louise Fazenda 4. George Walsh
5. Lya de Putti 6. Reginald Denny
7. Ken Maynard 8. Laura La Plante
9. Dolores del Rio 10. Norma Shearer
11. Lois Wilson 12. Ramon Novarro).
Book cover, 1928

Tempest. Herald, 1928

*In the 1920s and 1930s films were
announced by special programs and
colorful heralds.*

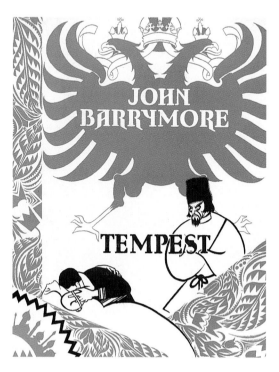

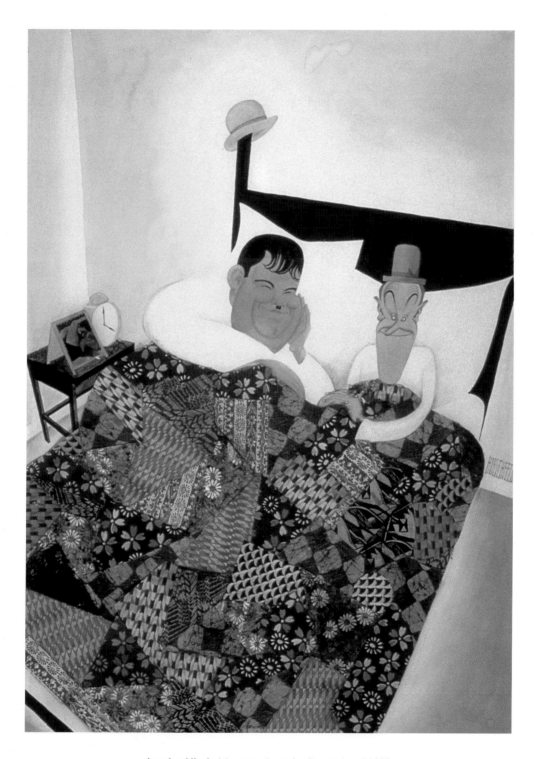

Laurel and Hardy. Ink, watercolor, and collage on board, 1928

The quilt in this collage is made of wallpaper samples. Hirschfeld would re-create this image for an M-G-M yearbook seven years later, but replacing the photograph of the wrestlers on the table with a picture of Garbo.

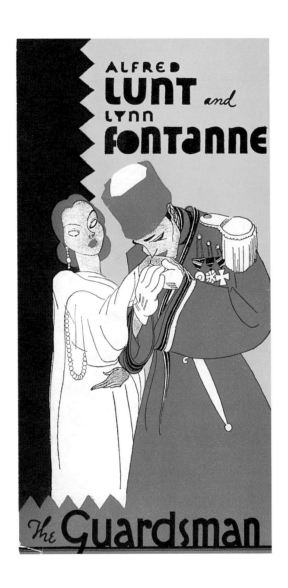

JOHN GILBERT AND GRETA GARBO IN *Love*

JOHN GILBERT established himself as one of the outstanding figures in motion pictures by his performances in "The Merry Widow" and "The Big Parade." Greta Garbo, blonde, statuesque and beautiful, a personification of slumbering passion, was welcomed by film audiences as a new and fascinating type. Less than a year after she had come to this country from Sweden she was made a star.

"Flesh and the Devil," in which these two players were paired, had a remarkable success both in this country and abroad. It earned the somewhat uncommon distinction of having proved itself both an artistic and a commercial

Left: *The Guardsman.* Herald, 1931
Right: *Love.* Herald, 1927

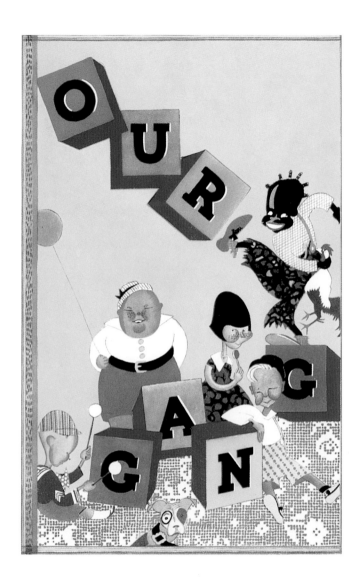 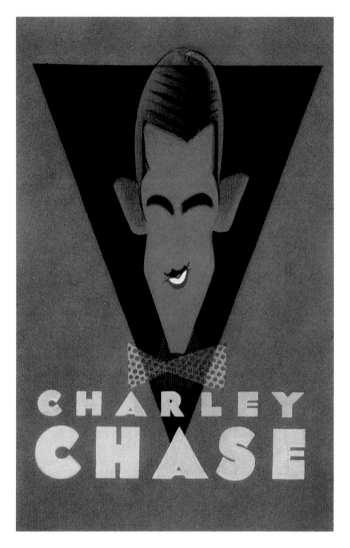

Left: **Our Gang.** Right: **Charley Chase.** Illustrations in M-G-M yearbook for short films, 1930

M-G-M published a variety of bound books to promote their product to exhibitors. In 1930 a yearbook devoted exclusively to upcoming short films was profusely illustrated with Hirschfeld artwork.

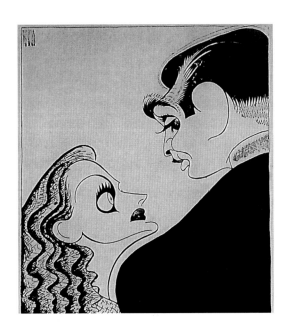

Dancing Lady (with Joan Crawford and Clark Gable). Caricature for pressbook, 1933. Collection of the Academy of Motion Picture Arts and Sciences

Queen Christina (with Greta Garbo and John Gilbert). Caricature for pressbook, 1933. Collection of the Academy of Motion Picture Arts and Sciences

Caricature was a perfect logo for the period. It immediately suggested a celebrity's image while gently satirizing his personality, which created a sense of intimacy with the subject.

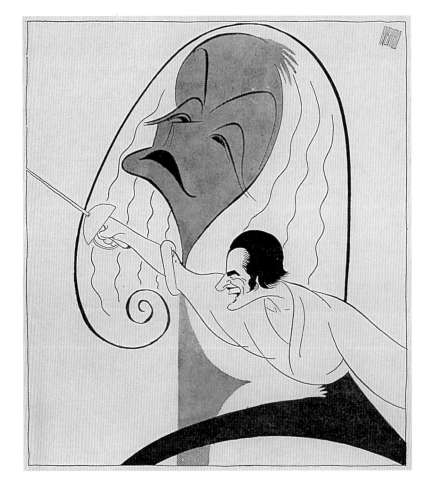

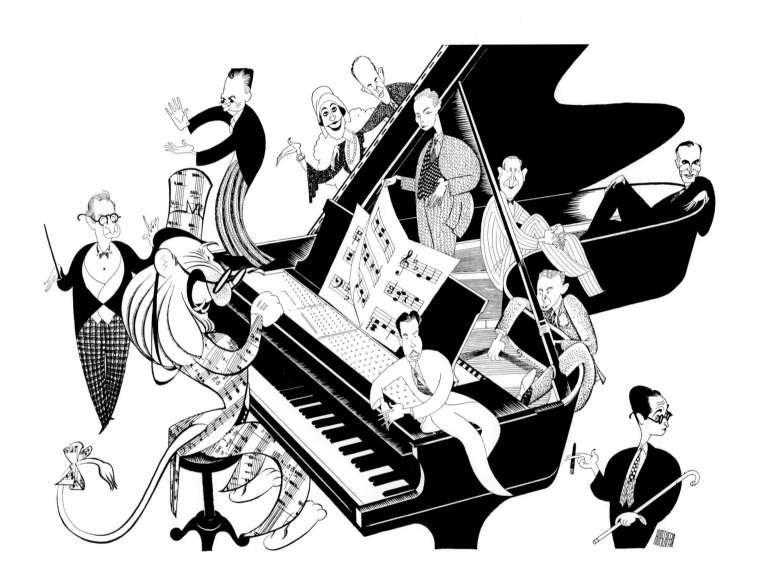

M-G-M Composers. Vintage printed material, c. 1933

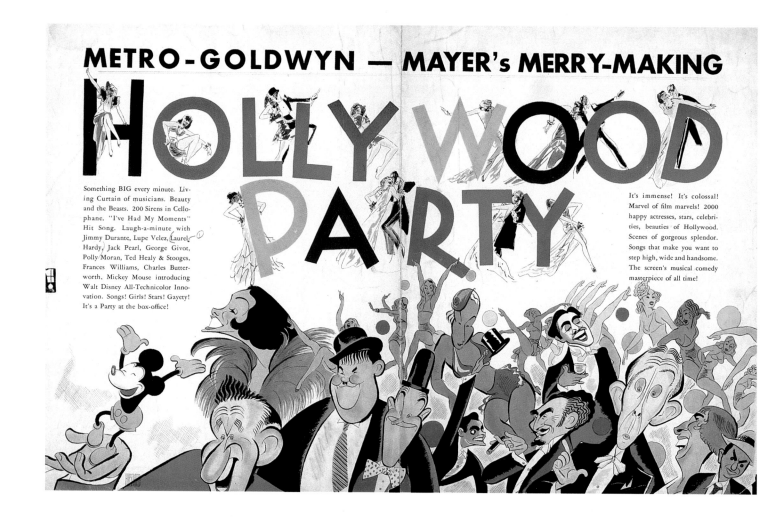

METRO-GOLDWYN — MAYER's MERRY-MAKING

HOLLYWOOD PARTY

Something BIG every minute. Living Curtain of musicians. Beauty and the Beasts. 200 Sirens in Cellophane. "I've Had My Moments" Hit Song. Laugh-a-minute with Jimmy Durante, Lupe Velez, Laurel-Hardy, Jack Pearl, George Givot, Polly Moran, Ted Healy & Stooges, Frances Williams, Charles Butterworth, Mickey Mouse introducing Walt Disney All-Technicolor Innovation. Songs! Girls! Stars! Gayety! It's a Party at the box-office!

It's immense! It's colossal! Marvel of film marvels! 2000 happy actresses, stars, celebrities, beauties of Hollywood. Scenes of gorgeous splendor. Songs that make you want to step high, wide and handsome. The screen's musical comedy masterpiece of all time!

Hollywood Party. Trade ad, 1934

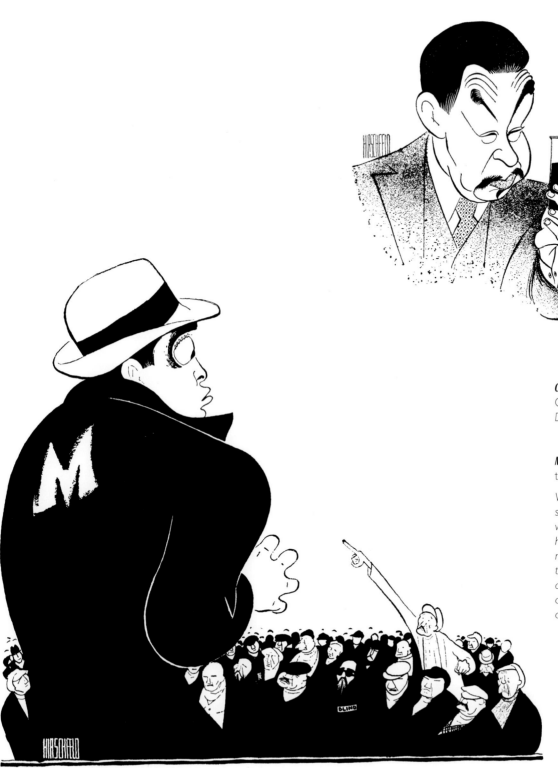

Charlie Chan's Secret (with Warner Oland) Published in the *Brooklyn Daily Eagle*, December 15, 1935

M (with Peter Lorre). Published in the *Herald Tribune*, April 9, 1933

While much of Hirschfeld's movie studio work during the 1930s was for musicals and comedies, he frequently drew dramas and mysteries for the newspapers. In that era, only the New York Times, among New York newspapers, did not commission Hirschfeld drawings of films for their pages.

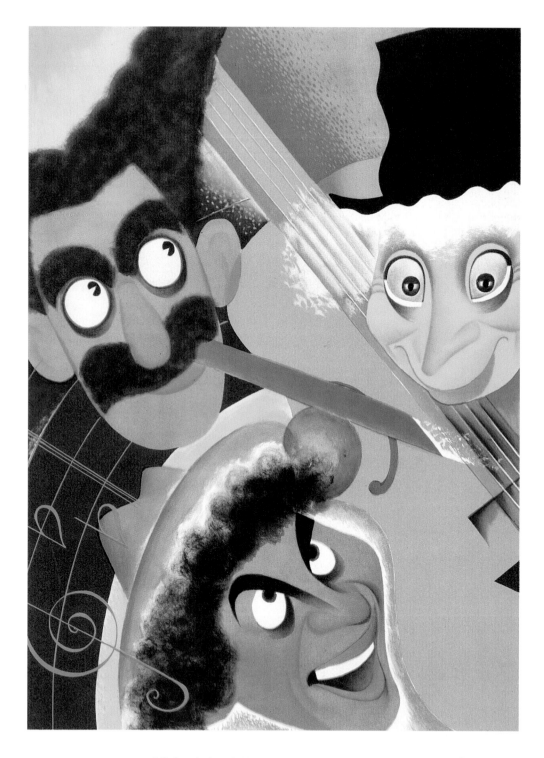

A Night at the Opera (with the Marx Brothers). Trade ad, 1935

"They had a wild surrealistic quality that hit a nerve with people," says Hirschfeld. While he knew Groucho the best, his favorite was Harpo. Chico "had the personality of a bookkeeper." Hirschfeld felt they were "completely unpredictable. To go out with them was to take your life in your own hands."

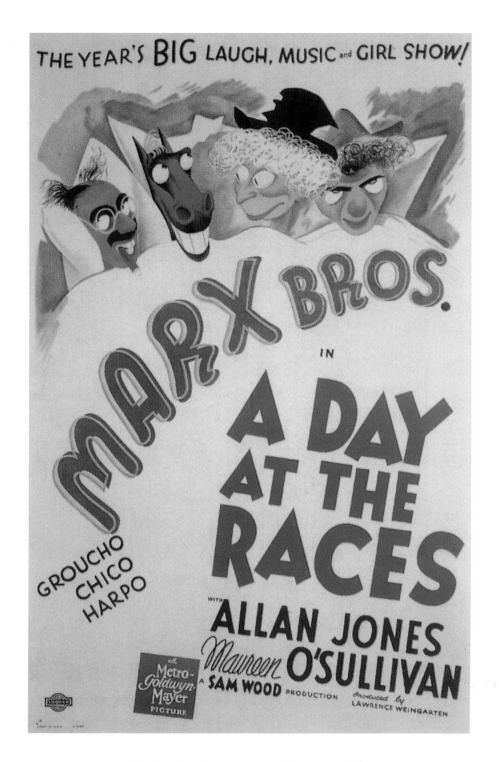

A Day at the Races. One-sheet poster, 1937. Private collection

*Hirschfeld supplied images for the entire campaign of the Marx Brothers' second effort for M-G-M,
which included seven posters, newspaper ads, heralds, and trade ads.*

Swiss Miss (with Laurel and Hardy). Trade ad, 1934

Hirschfeld has always enjoyed the early film comedians because "they invented themselves. They were much easier to do, to establish a symbol for."

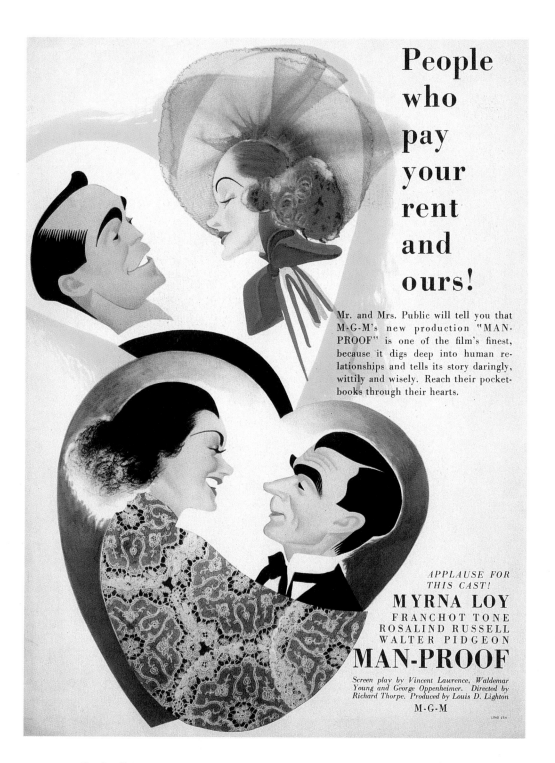

Man-Proof (with Myrna Loy, Franchot Tone, Rosalind Russell, and Walter Pidgeon). Trade ad, 1937

*Hirschfeld continually experimented with collage in his work, frequently employing
doilies to serve as dresses, and other material for clothes and hair.*

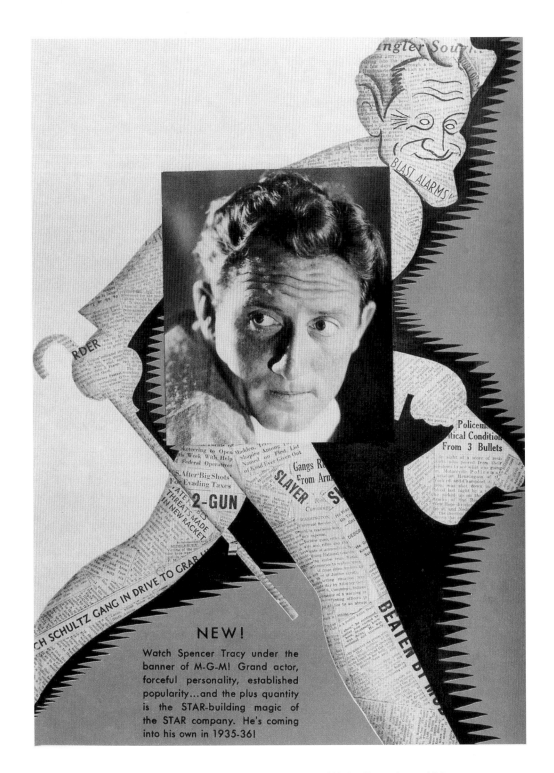

Spencer Tracy. Trade ad, 1935. Collection of the Academy of Motion Picture Arts and Sciences

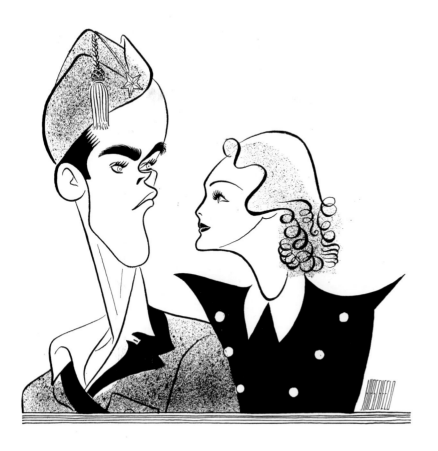

Blockade (with Henry Fonda and Madeline Carroll). Caricature for pressbook, 1938

Hirschfeld first drew Fonda in 1934 in an early stage success, The Farmer Takes a Wife, *which became the actor's first film. Over the years he depicted Fonda a number of times, including the actor's last appearance on screen in* On Golden Pond.

The Adventures of Marco Polo (with Sigrid Gurie, Gary Cooper, and Ernest Truex). Caricature for pressbook, 1938

Al Hirschfeld, Famous Caricaturist, Sketches Preview Impressions of Capra's "You Can't Take It With You"

Finds All The Elements of Drama and Romance in Pulitzer Prize Play

Caricaturist Al Hirschfeld, whose pen-and-ink talents have taken him to the romantic shores of Bali and back to the purlieus of New York, has found, in Hollywood's interpretation of the Pulitzer Prize-winning play, "You Can't Take It With You," a seemingly endless source of artistic inspiration.

Sketched World Personalities

Hirschfeld's efforts at limning the fads and foibles of the current scene have found favor in such divergent centers as Paris in France and Paris, Kentucky. His keen touch is recognized in London, England, and in the smallest hamlet in the West. His pen has etched the characteristics of the world's best-known personalities, from the hirsute brilliance of George Bernard Shaw, to the too-evident underlip of Maurice Chevalier and the pendant pout of Greta Garbo.

In bringing Frank Capra's production of "You Can't Take It With You" before his pen, Mr. Hirschfeld found, in the activities at the Columbia studio, a wealth of material for his talents. He has sketched, brilliantly and effectively, the kindly humanity of Lionel Barrymore as he portrays the sympathetic and understanding Grandpa Vanderhof. Hirschfeld penned the amorous enthusiasms of Jean Arthur and James Stewart with eloquent strokes;

he has portrayed the ballet-dancing Mischa Auer, the irascible Edward Arnold, the terpsichorean Ann Miller, the hobbyists Spring Byington and Donald Meek and the posing Halliwell Hobbes with shrewd appreciation of the qualities that have made the George S. Kaufman-Moss Hart play so resounding a Broadway success.

Reveals Film's Humaneness

Inspirational in theme, "You Can't Take It With You," as the Hirschfeld illustrations on this page show, has been more than an inspiration to the world-renowned caricaturist. The drawings reveal the players in this Columbia production in moods that portray, vividly and affectionately, the humaneness and dramatic values in the motion picture.

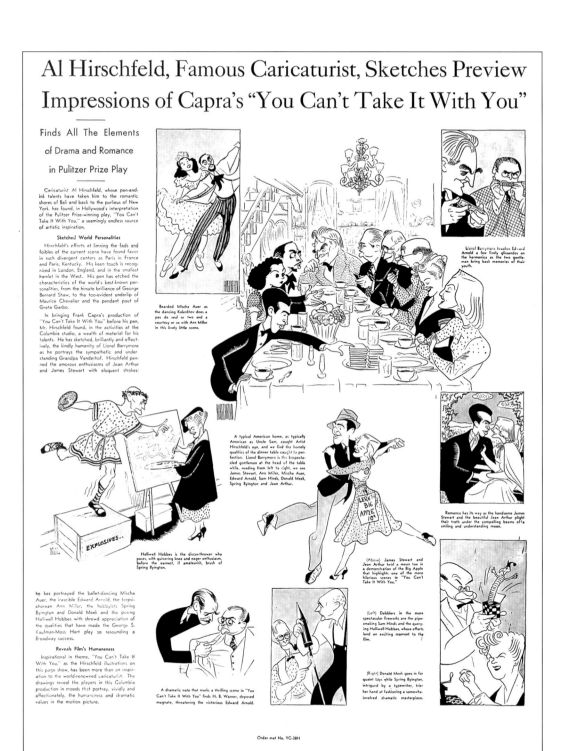

Bearded Mischa Auer as the dancing Kolenkhov does a pas de seul or two and a courtesy or so with Ann Miller in this lively little scene.

Lionel Barrymore teaches Edward Arnold a few lively glissandos on the harmonica as the two gentlemen bring back memories of their youth.

A typical American home, as typically American as Uncle Sam, caught Artist Hirschfeld's eye, and we find the homely qualities of the dinner table caught to perfection. Lionel Barrymore is the bespectacled gentleman at the head of the table while, reading from left to right, we see James Stewart, Ann Miller, Mischa Auer, Edward Arnold, Sam Hinds, Donald Meek, Spring Byington and Jean Arthur.

Halliwell Hobbes is the discus-thrower who poses, with quivering knee and eager enthusiasm, before the earnest, if amateurish, brush of Spring Byington.

(Above) James Stewart and Jean Arthur twirl a mean toe in a demonstration of the Big Apple that highlights one of the more hilarious scenes in "You Can't Take It With You."

Romance has its way as the handsome James Stewart and the beautiful Jean Arthur plight their troth under the compelling beams of a smiling and understanding moon.

(Left) Dabblers in the more spectacular fireworks are the pipe-smoking Sam Hinds and the querying Halliwell Hobbes, whose efforts lend an exciting moment to the film.

A dramatic note that marks a thrilling scene in "You Can't Take It With You" finds H. B. Warner, deposed magnate, threatening the victorious Edward Arnold.

(Right) Donald Meek goes in for quaint toys while Spring Byington, intrigued by a typewriter, tries her hand at fashioning a somewhat involved dramatic masterpiece.

Order mat No. YC-38H

You Can't Take It with You. 1938

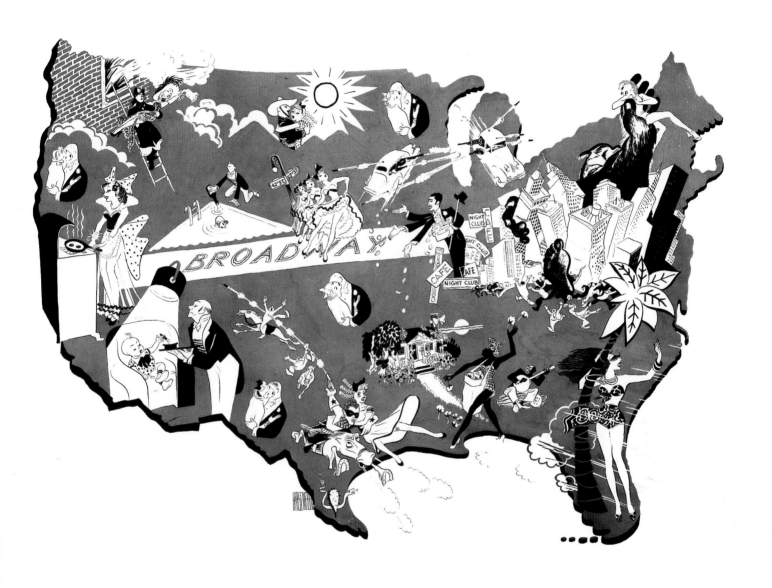

"Hollywood's America." Ink and gouache on board. Published in the *New York Times Magazine*, December 31, 1939

Representing the movie capital's idea of cultural diversity in America, Hirschfeld employed
a variety of clichés to illustrate the caption: "In 1939 it was limited geographically to such points as
Hollywood, Broadway and a vague district called 'Out West.'"

The Wizard of Oz. 1939

Hirschfeld told much of the story of the film musical in these letters, which appeared on the one-sheet poster, lobby card, and lobby displays.

The Wizard of Oz. Campaign book back cover, 1939. Courtesy Jay Scarfone and William Stillman, Wizard of Oz Collection

Hirschfeld created all but the three-sheet (A) and the twenty-four-sheet posters for the film's original campaign. These were his first drawings of Judy Garland. Hirschfeld had previously drawn Ray Bolger, Bert Lahr, and Jack Haley in their many successes on the New York stage.

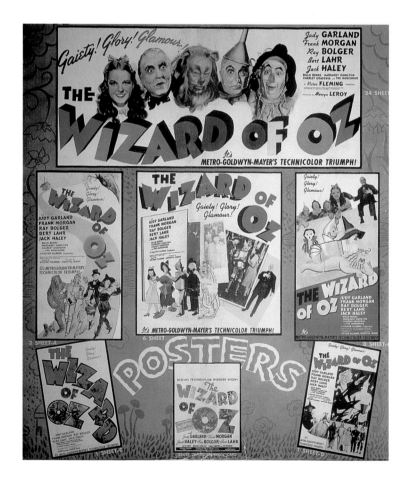

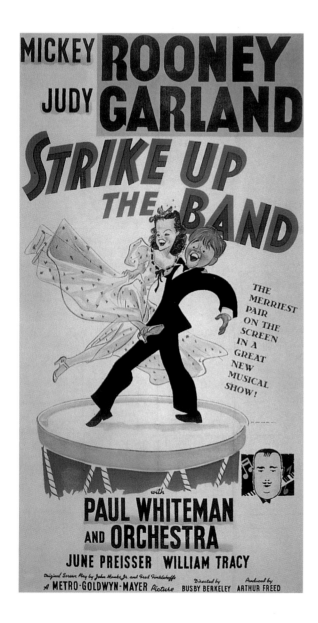

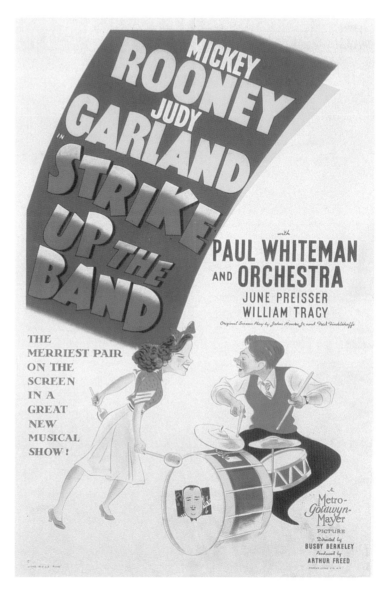

Left: **Strike Up the Band.** One-sheet poster, 1940. Private collection
Right: **Strike Up the Band.** One-sheet poster, 1940. Collection of the Academy of Motion Picture Arts and Sciences

These are two of the three posters Hirschfeld created for this Judy and Mickey musical.
He did not draw the Paul Whiteman logo.

The Great Dictator
(with Charlie Chaplin and
Jack Oakie). Caricatures for
souvenir program, 1941.
Collection of the Academy
of Motion Picture Arts
and Sciences

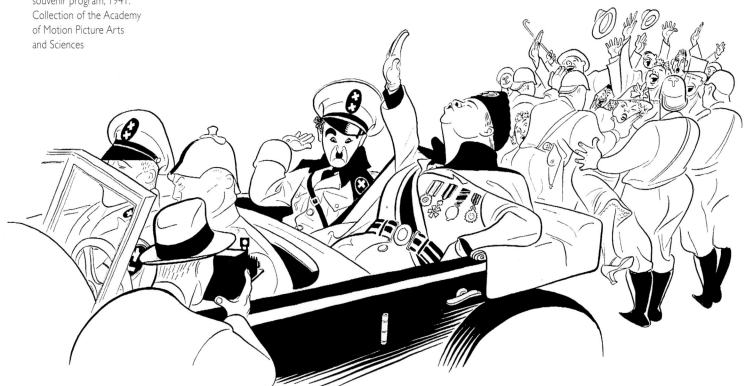

Charlie Chaplin. Ink and gouache on board. Published in the *New York Times Magazine*, July 26, 1942

*On a visit with Chaplin in 1942, Hirschfeld wrote: "I watched this man who dared to be simple, as fascinated and amused as the first time
I saw him in the movies. He talked and thought pictorially, knowing every second how he looked and not caring what he said."*

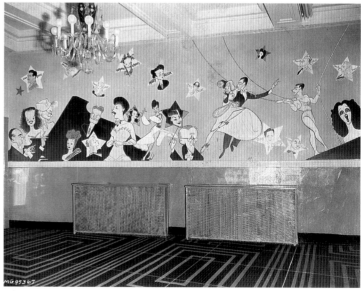

Thousands Cheer. Half-sheet poster, 1943. Collection of the Academy of Motion Picture Arts and Sciences

Thousands Cheer. Marquee and lobby interior of the Astor Theatre in Manhattan, 1943

Hirschfeld created thirty-four portraits for this star-studded wartime effort. The portraits were used on posters, lobby displays, and theater marquees.

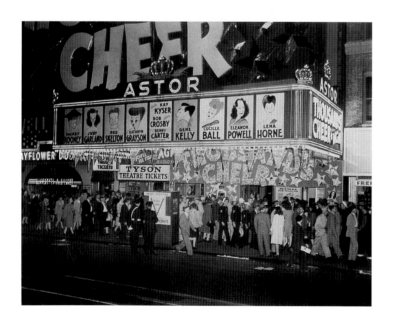

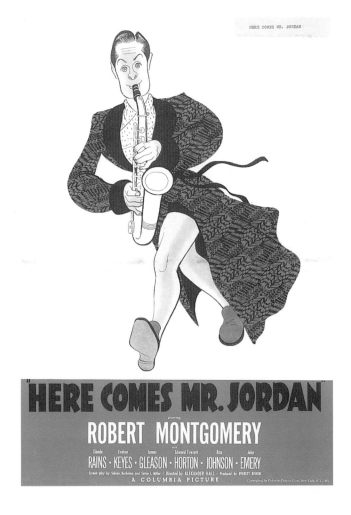

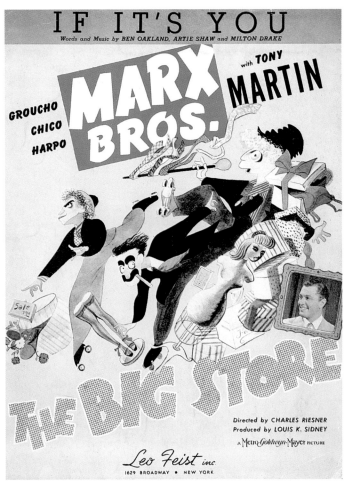

Here Comes Mr. Jordan. Pressbook cover, 1941.
Collection of the Academy of Motion Picture Arts and Sciences

The Big Store. Sheet music, 1941

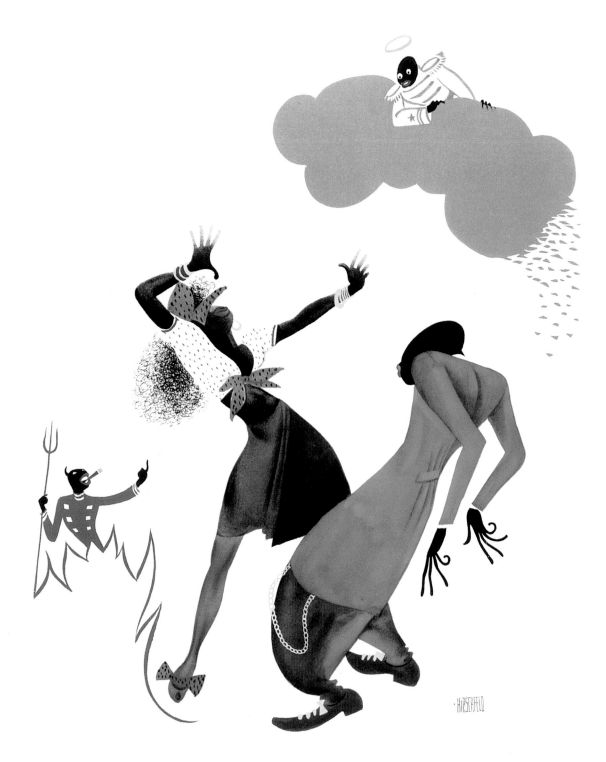

Cabin in the Sky. 1943

This colorful campaign recalls Hirschfeld's lithographs published in Harlem As Seen by Hirschfeld *in 1941.*
Hirschfeld had also drawn many of the images for M-G-M's first all-black musical, Hallelujah!, *in 1929.*

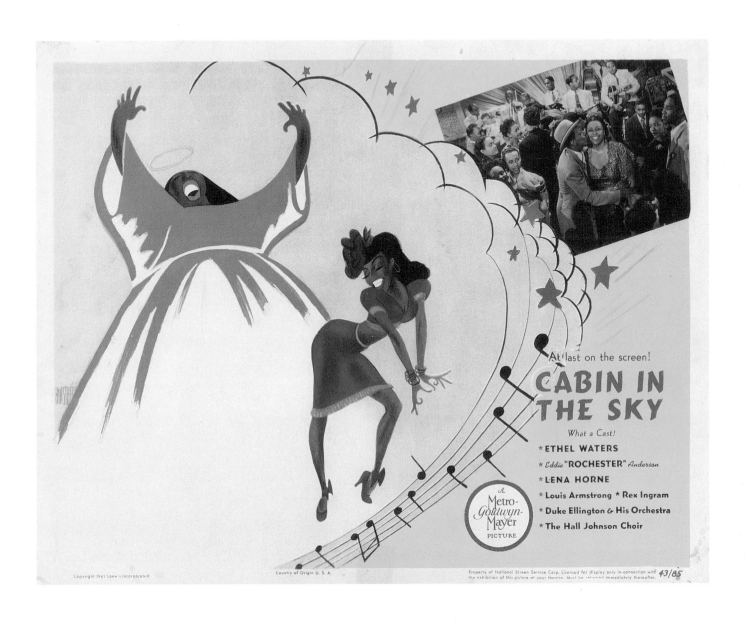

Cabin in the Sky. Lobby card, 1943. Collection of the Academy of Motion Picture Arts and Sciences

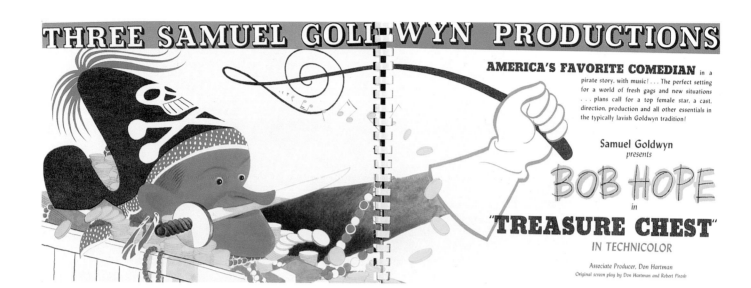

THREE SAMUEL GOLDWYN PRODUCTIONS

AMERICA'S FAVORITE COMEDIAN in a pirate story, with music! . . . The perfect setting for a world of fresh gags and new situations . . . plans call for a top female star, a cast, direction, production and all other essentials in the typically lavish Goldwyn tradition!

Samuel Goldwyn
presents

BOB HOPE

in

"TREASURE CHEST"

IN TECHNICOLOR

Associate Producer, Don Hartman
Original screen play by Don Hartman and Robert Pirosh

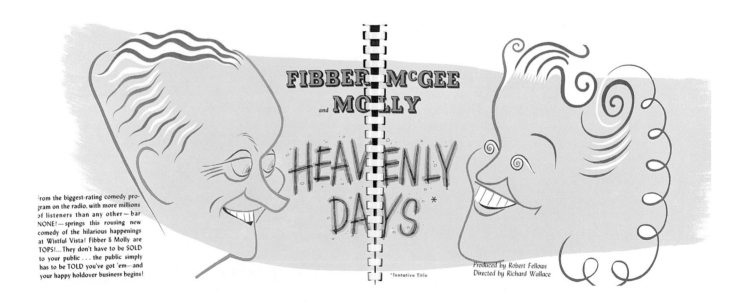

FIBBER McGEE and **MOLLY**

HEAVENLY DAYS *

From the biggest-rating comedy program on the radio, with more millions of listeners than any other — bar NONE! — springs this rousing new comedy of the hilarious happenings at Wistful Vista! Fibber & Molly are TOPS!...They don't have to be SOLD to your public . . . the public simply has to be TOLD you've got 'em—and your happy holdover business begins!

*Tentative Title

Produced by Robert Fellows
Directed by Richard Wallace

Treasure Chest (released as *The Princess and the Pirate*). ***Heavenly Days.*** Illustrations in RKO yearbook, 1943.
Collection of the Academy of Motion Picture Arts and Sciences

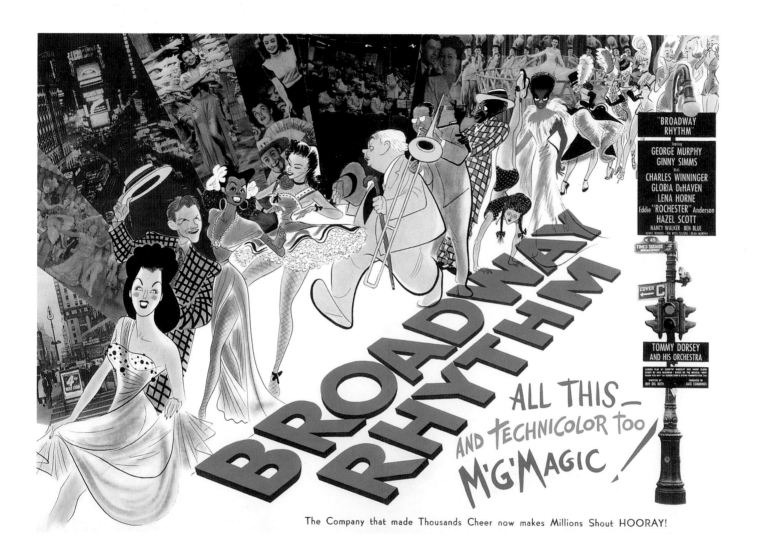

Broadway Rhythm. Trade ad, 1943

Star Spangled Rhythm (with, clockwise from top left: Victor Moore, Bob Hope, Vera Zorina, Rochester, Veronica Lake, Dorothy Lamour, Paulette Goddard, and Betty Hutton). Caricature for pressbook, 1943

Get out the ropes for Frank Sinatra, Kathryn Grayson, Gene Kelly, Jose Iturbi in M★G★M's "Anchors Aweigh," Tuneful, Terrific and Technicolor!

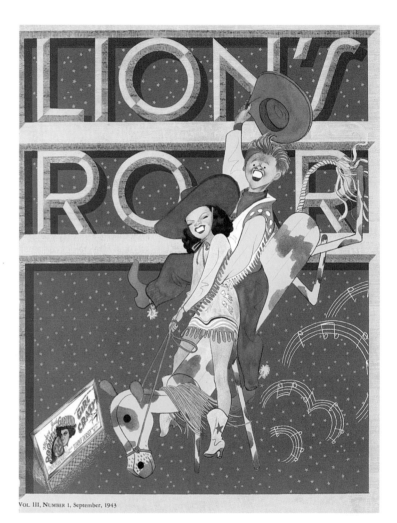

Vol. III, Number 1, September, 1943

Anchors Aweigh (with Frank Sinatra, Gene Kelly, and Kathryn Grayson). Trade ad, 1945.
Collection of the Academy of Motion Picture Arts and Sciences

Girl Crazy (with Judy Garland and Mickey Rooney). Magazine cover, 1943.
Collection of the Academy of Motion Picture Arts and Sciences

*For "the big musical with Broadway flair and a Western air," Hirschfeld's portrait of Garland and Rooney
appeared on posters, programs, and M-G-M's magazine for exhibitors, The Lion's Roar.*

Clockwise from top left: **Elizabeth Taylor, Mickey Rooney, Jackie "Butch" Jenkins, and Donald Crisp in** *National Velvet*. Trade ad, 1944. Collection of the Academy of Motion Picture Arts and Sciences

In Hirschfeld's account book, he listed by name the three male actors in these unique pastel portraits, but only "a girl's head" for the then-unknown Elizabeth Taylor.

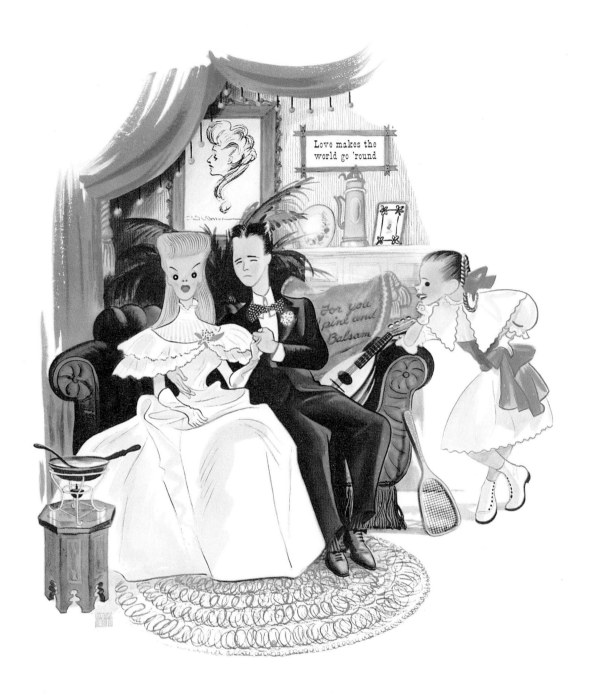

Meet Me in St. Louis (with Judy Garland, Tom Drake, and Margaret O'Brien). Trade ad, 1946.
Collection of the Academy of Motion Picture Arts and Sciences

Producer Fred Finklehoffe saw to it that the Kensington Street house Judy Garland sings
about has the same address as the house where Hirschfeld grew up in St. Louis.

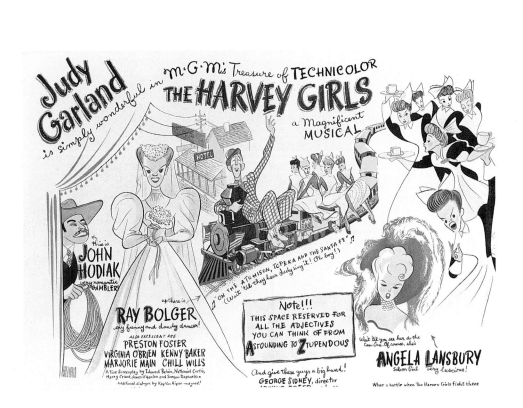

The Harvey Girls (with Judy Garland, Ray Bolger, John Hodiak, and Angela Lansbury). Trade ad, 1946. Collection of the Academy of Motion Picture Arts and Sciences

The Paleface (with Bob Hope and Jane Russell). Illustration in press-book, 1948

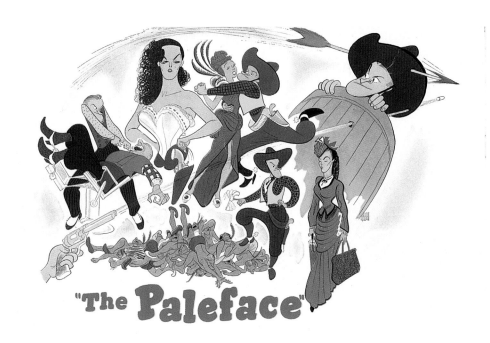

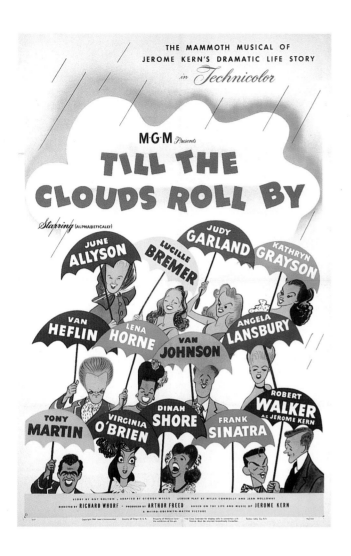

Till the Clouds Roll By. One-sheet poster, 1946. Collection of the Academy of Motion Picture Arts and Sciences

Hirschfeld drew twenty-four portraits and figure drawings for this fictionalized musical biography of Jerome Kern.

Bad Bascomb (with Wallace Beery and Margaret O'Brien). Trade ad, 1946

"Hollywood Types: The Producer." Pen and ink
on board. Published in *Holiday*, January 1949

*For an illustrated article on "the fauna of
Hollywood as caught in their native haunts by
explorer-artist" Hirschfeld, he captured the stereo-
typical Producer. The original caption explains that
the Producer is convinced he must oversee every
aspect of the studio, as well as get away to the
Waldorf "or the Riviera for a few months every
now and then to keep from collapsing. Reconciling
such dissimilarities is his ulcerous dilemma."*

Cary Grant. Published in *Seventeen*, July 1948

*From its first issue, Seventeen magazine regularly
featured Hirschfeld drawings of teen idols. First
they were images of jazz musicians, but by the
late 1940s they were all of movie stars.*

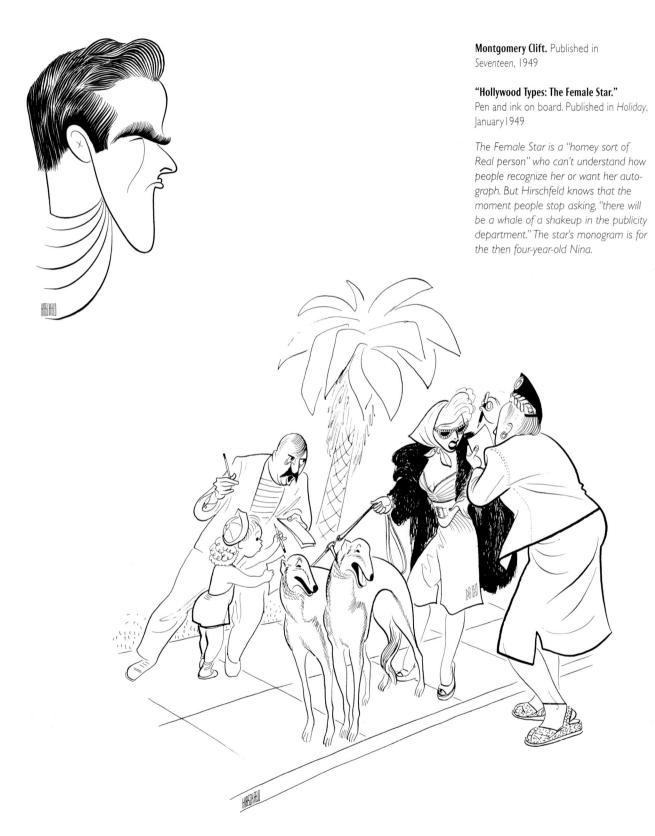

Montgomery Clift. Published in *Seventeen*, 1949

"Hollywood Types: The Female Star."
Pen and ink on board. Published in *Holiday*, January 1949

The Female Star is a "homey sort of Real person" who can't understand how people recognize her or want her autograph. But Hirschfeld knows that the moment people stop asking, "there will be a whale of a shakeup in the publicity department." The star's monogram is for the then four-year-old Nina.

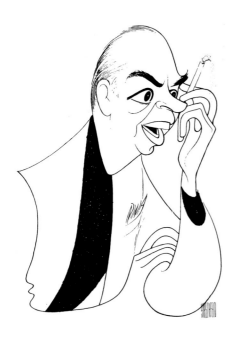

Vincente Minnelli. Pen and ink on board, 1983. Private collection

In Minnelli's first decade of filmmaking, Hirschfeld captured many of his stylish films, including Cabin in the Sky, Ziegfeld Follies, Meet Me in St. Louis, Yolanda and the Thief, Undercurrent, *and* The Pirate.

An American in Paris (with Leslie Caron and Gene Kelly). 1951

Hirschfeld first drew Gene Kelly when the actor was still doing summer-stock theater. After Kelly's success in Pal Joey on Broadway, Hirschfeld drew him in many of his most significant films.

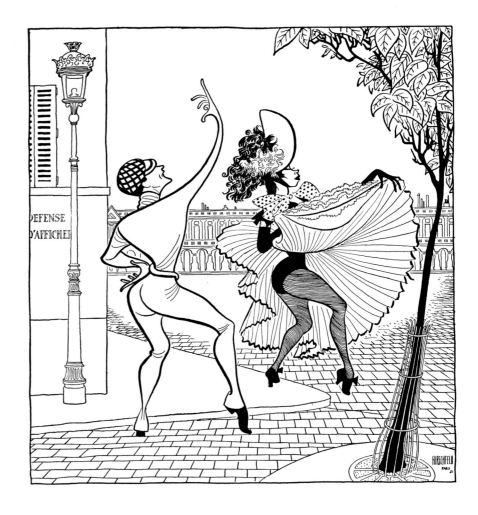

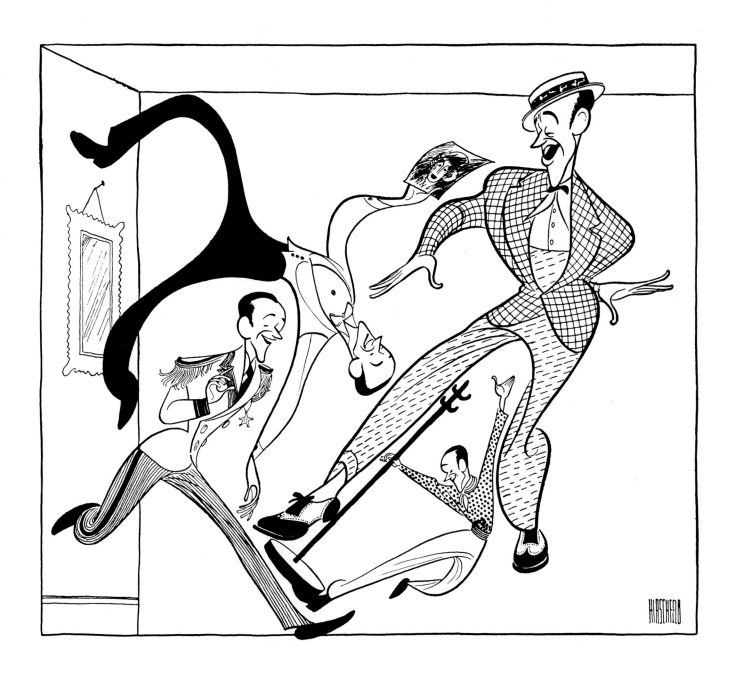

Royal Wedding (with Fred Astaire), 1951

*Movement is the key component in Hirschfeld's work. His ability to transform a
two-dimensional space into a kinetic delineation of a lively art is second to none.*

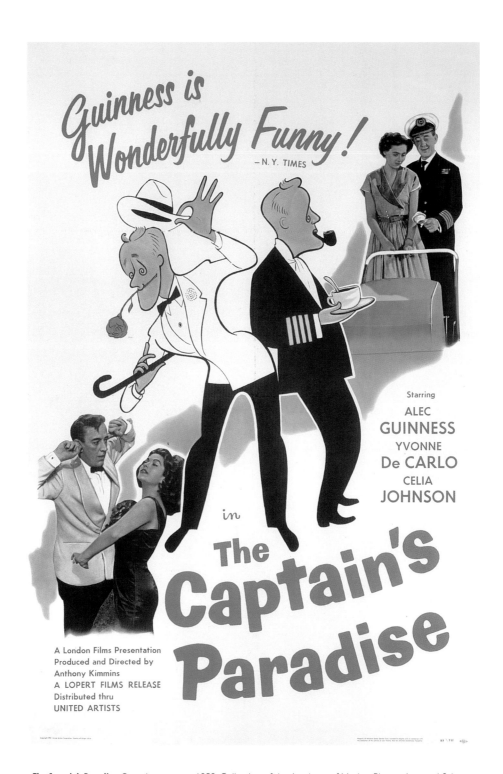

The Captain's Paradise. One-sheet poster, 1953. Collection of the Academy of Motion Picture Arts and Sciences

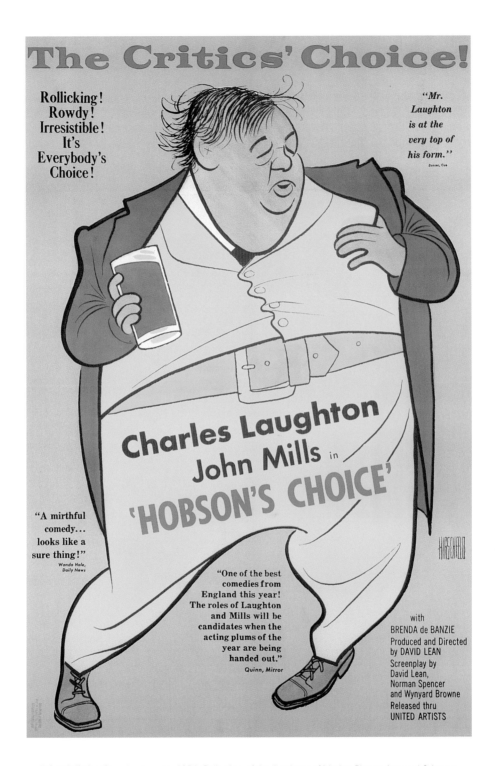

Hobson's Choice. One-sheet poster, 1954. Collection of the Academy of Motion Picture Arts and Sciences

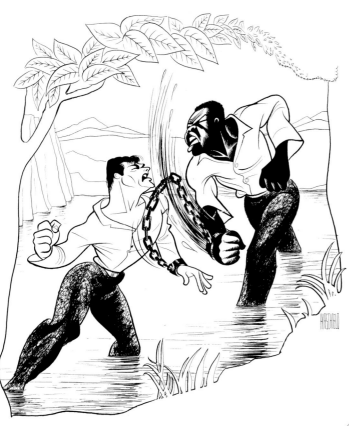

The Defiant Ones (with Tony Curtis and Sidney Poitier). Pen and ink on board, 1958

In this study in black and white, Hirschfeld suggests trees to frame the composition. Critic John Russell wrote, "[Hirschfeld] can make the untouched white of the page work for him as a henchman and a friend."

The Fugitive Kind (with Marlon Brando, Anna Magnani, and Joanne Woodward). Pen and ink on board, 1960. Paul Vindel Collection, Special Collections, Boston University

Tennessee Williams was a great fan of Hirschfeld's work, and the artist drew many of his productions, including this film adapted from Williams's Orpheus Descending.

I Want to Live (with Susan Hayward). Pen and ink on board, 1958

Hirschfeld has long had a fascination with hands, utilizing them to express a wide range of emotions in his drawings.

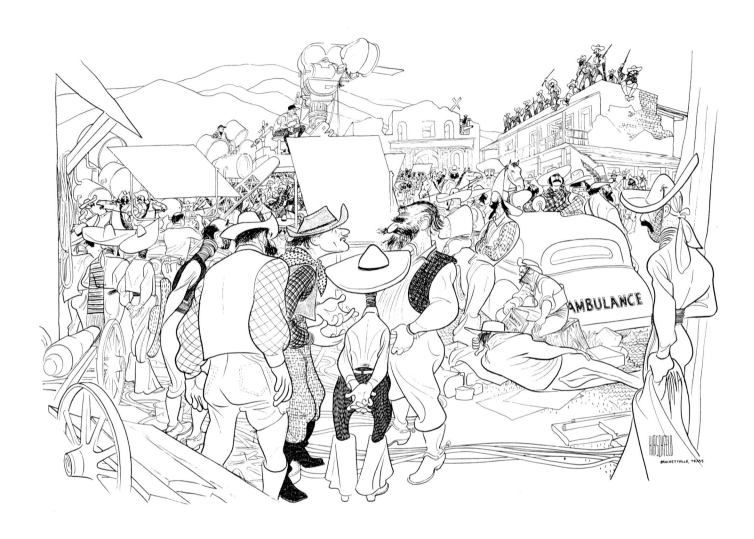

On the set of *The Alamo* (with John Wayne and John Dierkes). Pen and ink on board, 1960. The Performing Arts Collection, The Harry Ransom Humanities Research Center, University of Texas at Austin

Hirschfeld recalls with a laugh John Wayne angrily demanding to know who allowed a helicopter to violate the airspace of one of the epic battle scenes he directed. Wayne was told it was there to bring his lunch, which had been flown in from Hollywood.

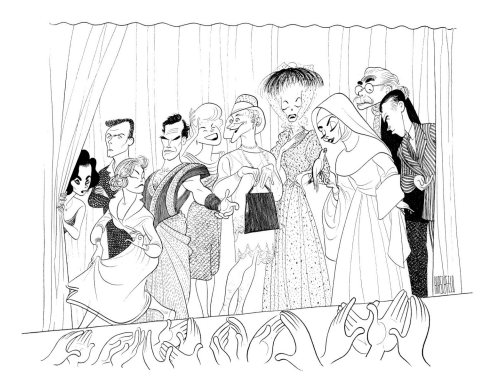

Academic Award Hopefuls. Pen and ink on board, 1960. Davenport Museum of Art, Iowa

The best actor and best actress nominees of 1959 were Elizabeth Taylor in Suddenly Last Summer, *Laurence Harvey and Simone Signoret in* Room at the Top, *Charlton Heston in* Ben Hur, *Doris Day in* Pillow Talk, *Jack Lemmon in* Some Like it Hot, *Katharine Hepburn in* Suddenly Last Summer, *Audrey Hepburn in* The Nun's Story, *Paul Muni in* The Last Angry Man, *and James Stewart in* Anatomy of a Murder.

On the set of *West Side Story*
(with Robert Wise and Jerome Robbins). Pen and ink on board, 1960. Melvin R. Seiden Collection, The Harvard Theatre Collection, The Houghton Library

The Manchurian Candidate
(with Frank Sinatra, Laurence Harvey, Janet Leigh, Angela Lansbury, and Henry Silva), 1962

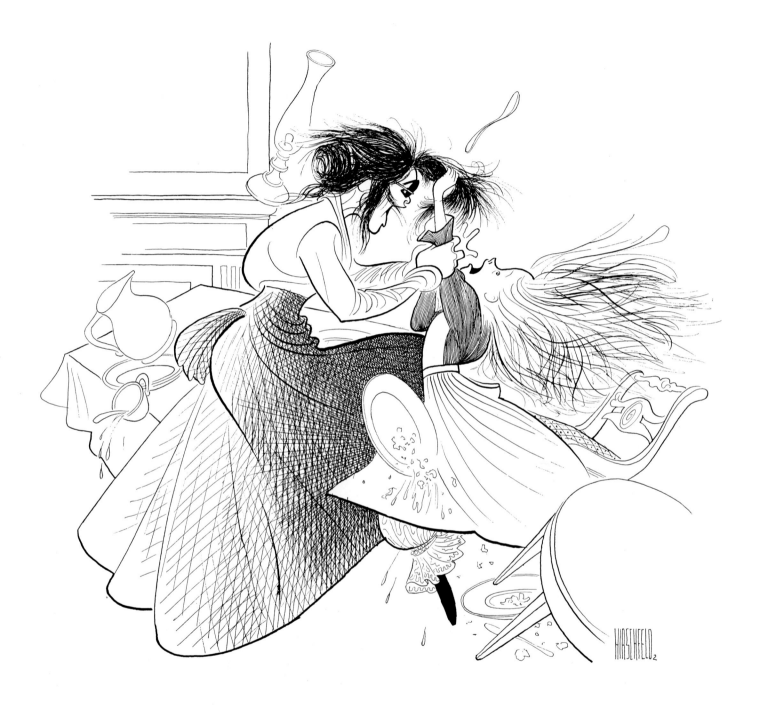

The Miracle Worker (with Anne Bancroft and Patty Duke). Pen and ink on board, 1962.
Melvin R. Seiden Collection, The Harvard Theatre Collection, The Houghton Library

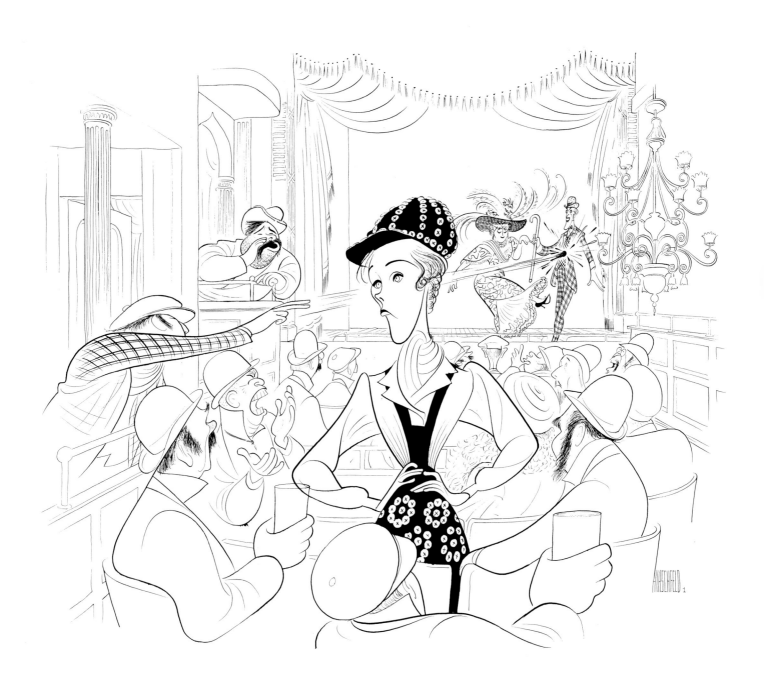

Star! (with Julie Andrews). Pen and ink on board, 1968

Hirschfeld has drawn Julie Andrews over fifty times, more than any other performer. He has captured her entire career, from her first appearance on a New York stage, to her greatest films, to her return to Broadway.

Where's Poppa? (with George Segal and Ruth Gordon). Pen and ink on board. Published in the *New York Times*, November 8, 1970

Butterflies Are Free (with Eileen Heckart, Edward Albert, and Goldie Hawn). Pen and ink on board. Published in the *New York Times*, July 2, 1972

Within days after this drawing was published, Hirschfeld received a note from Goldie Hawn requesting the drawing: "This is not something I often do, as I don't like most drawings or caricatures of myself; but yours is quite different. When I look at it, it always reminds me of the great experience I had [in making the film]."

Clockwise from top left:

Woody Allen. Pen and ink on board. Published in the *New York Times*, December 24, 1967

Lucille Ball in *Mame*. Pen and ink on board, 1974. Private collection

As the age of the illustrated poster ended, Hirschfeld drawings were used in newspaper and magazine publicity since they attracted an audience inured to traditional advertising.

Henry Fonda in *The Grapes of Wrath*. Pen and ink on board, 1977. The James Purdy Collection. Courtesy of George Goodstadt

One of the forty-eight drawings that IBM commissioned as part of a nationwide advertising campaign for a television presentation of selected film classics.

Garbo. Pen and ink on board, 1982. Collection of Alexandra and George Goodstadt

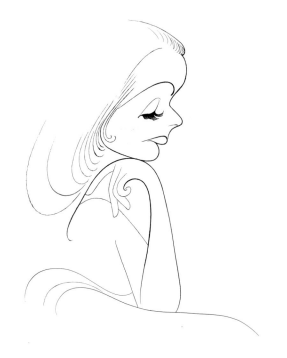

New York, New York (with Robert De Niro and Liza Minnelli). Image from one-sheet poster, 1977. Collection of the Academy of Motion Picture Arts and Sciences

The Goodbye Girl (with Marsha Mason, Richard Dreyfuss, and Quinn Cummings), 1977

The set decorator for the film evoked New York's performing-arts culture by putting a Hirschfeld exhibition poster featuring a number of his drawings on the wall of the apartment of Marsha Mason's character.

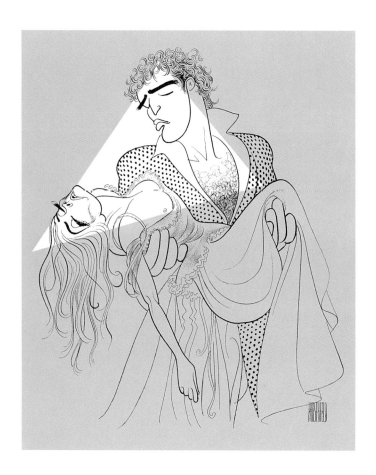

A Streetcar Named Desire (with Marlon Brando and Vivien Leigh). Illustrations from Limited Edition Book Club book, 1982

Elia Kazan. Pen and ink on board. Published in *Colliers*, May 27, 1955

Kazan was an actor in the Group Theater when Hirschfeld met the soon-to-be legendary director. Friends for more than sixty years, Hirschfeld used Kazan's film version of A Streetcar Named Desire *as visual reference for an illustrated edition of the Tennesse Williams play.*

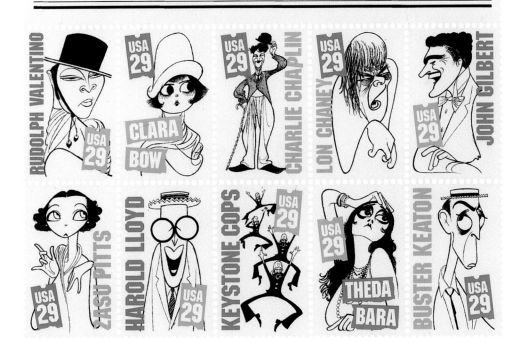

STARS OF THE
SILENT SCREEN

RUDOLPH VALENTINO

USA 29

CLARA BOW

USA 29

CHARLIE CHAPLIN

LON CHANEY

JOHN GILBERT

USA 29

ZASU PITTS

HAROLD LLOYD

USA 29

KEYSTONE COPS

USA 29

THEDA BARA

USA 29

BUSTER KEATON

USA 29

Stars of the Silent Screen. Set of ten United States postage stamps, 1994. Collection of the United States Postal Service

Above: **Theda Bara**. Pen and ink on board. Issued as a United States postage stamp, 1994. Collection of the United States Postal Service

Hirschfeld first drew Theda Bara when she signed with Selznick Pictures in 1923.

Left: **Buster Keaton.** Pen and ink on board. Issued as a United States postage stamp, 1994. Collection of the United States Postal Service

A self-described "vaudeville bum," Hirschfeld cut a week of school to see Houdini perform at the Palace. On the same bill was the Keaton family act. Later he would draw the actor's M-G-M films.

CAROL **BURNETT** MICHAEL **CAINE** DENHOLM **ELLIOTT** JULIE **HAGERTY** MARILU **HENNER** MARK **LINN-BAKER** CHRISTOPHER **REEVE** JOHN **RITTER** NICOLLETTE **SHERIDAN**

NOISES OFF
The comedy where everyone gets caught in the act.

TOUCHSTONE PICTURES and AMBLIN ENTERTAINMENT present in association with TOUCHWOOD PACIFIC PARTNERS I
CAROL BURNETT MICHAEL CAINE DENHOLM ELLIOTT JULIE HAGERTY MARILU HENNER MARK LINN-BAKER CHRISTOPHER REEVE
JOHN RITTER NICOLLETTE SHERIDAN A PETER BOGDANOVICH Picture "NOISES OFF" Music Adaptations by PHIL MARSHALL Co-Producer STEVE STARKEY
Executive Producers KATHLEEN KENNEDY and PETER BOGDANOVICH Based on the play by MICHAEL FRAYN Screenplay by MARTY KAPLAN
Produced by FRANK MARSHALL Directed by PETER BOGDANOVICH
AMBLIN ENTERTAINMENT PG-13 PARENTS STRONGLY CAUTIONED Some Material May Be Inappropriate for Children Under 13 Distributed by Buena Vista Pictures Distribution, Inc. ©TOUCHSTONE PICTURES and AMBLIN ENTERTAINMENT, INC. DOLBY STEREO Touchstone Pictures

Noises Off (with Michael Caine, Carol Burnett, Nicollette Sheridan, Christopher Reeve, John Ritter,
Mark Linn-Baker, Julie Hagerty, Denholm Elliott, and Marilu Henner). One-sheet poster, 1992.
Collection of the Academy of Motion Picture Arts and Sciences

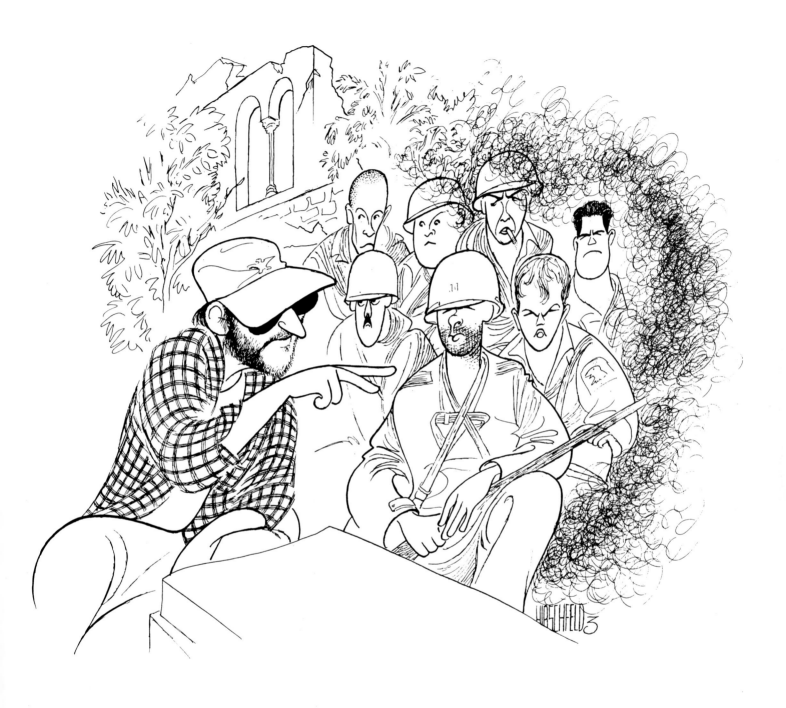

Steven Spielberg directs *Saving Private Ryan*. Pen and ink on board, 1999. Private collection

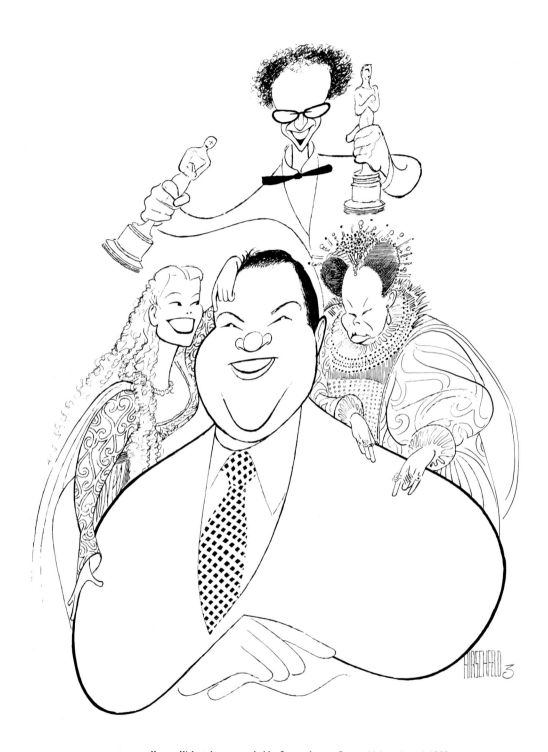

Harvey Weinstein surrounded by Oscar winners. Pen and ink on board, 1999

The co-chairman of Miramax films with Oscar winners for 1998: Roberto Begnini in Life is Beautiful, *which Miramax distributed; and Gwyneth Paltrow and Judi Dench in* Shakespeare in Love, *which Weinstein produced.*

Oscar Nominees. Pen and ink on board with colored gel overlay. Published in the *New York Times*, March 4, 2001

Clockwise from top left: The nominees for best actor and best actress of 2000 were *Russell Crowe in* Gladiator, *Ellen Burstyn in* Requiem for a Dream, *Ed Harris in* Pollock, *Geoffrey Rush in* Quills, *Julia Roberts in* Erin Brockovich, *Joan Allen in* The Contender, *Javier Bardém in* Before Night Falls, *Juliette Binoche in* Chocolat, *Tom Hanks in* Cast Away, *and Laura Linney in* You Can Count on Me.

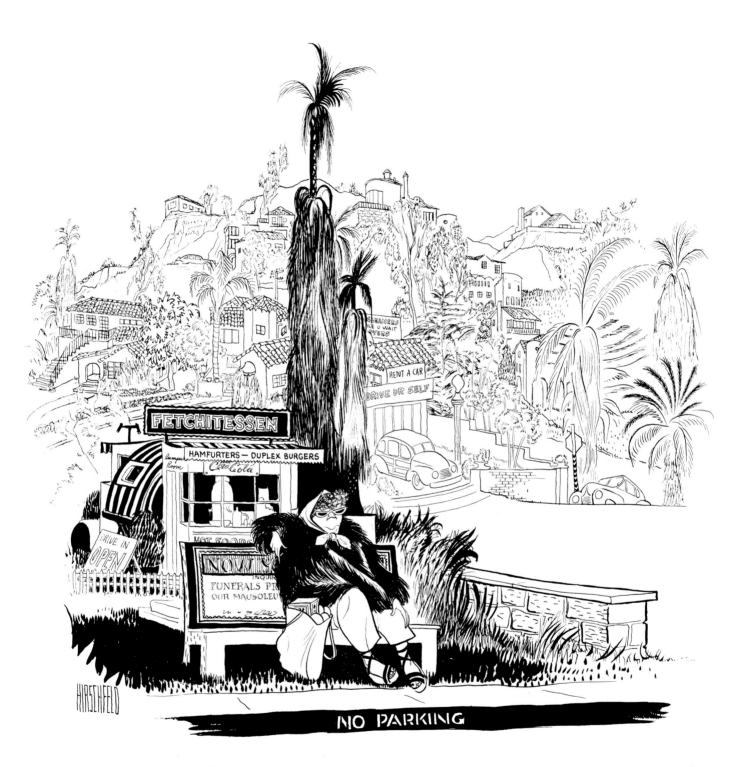

Hollywood. Illustration for *Westward Ha!* by S. J. Perelman. Pen and ink on board, 1947

Hirschfeld: A Film Chronology

1903 June 21 Born in St. Louis.

1914 Family moves to New York.

1920 Hired for $4 per week to clean brushes and run errands at Goldwyn Pictures Publicity Department. Soon becomes contributing artist.

1921 Hired by Universal for $75 per week.

1922 Hired as Art Director at Selznick Pictures.

1924 Selznick Pictures goes bankrupt. Shares studio with Miguel Covarrubias and works for Warner Bros. First caricatures of Charlie Chaplin for Pathé re-releases.

1925 April 25 First caricature of performers in Warner Bros. films published in the New York World.

1926 December 26 First theatrical caricature of Sacha Guitry published in Herald Tribune.

1927 Signs $15,000-per-year contract with M-G-M. Associated with the studio for the next thirty years.

1928 Spends six months in Russia interviewing the heads of Russian theater and film for an illustrated book that is eventually lost.

1932 Decisive moment in Bali. Gives up easel painting to concentrate on image in pure line. Chaplin's purchase of Bali watercolors provides the funds for Hirschfeld to return to New York.

1935 First drawing of the Marx Brothers for A Night at the Opera.

1938 Reviews Disney's Snow White for the New York Times. Writes: "The illusion created by a well-directed pen line is an art not to be confused with the gingerbread realities of Snow White."

1940 Reviews Disney's Pinocchio, again criticizing the attempt to replicate human figures in animation.

1942 In Hollywood to interview Chaplin for New York Times article, "Charles Chaplin—A Man with Both Feet in the Clouds." Also gathers material for "On the Hollywood Front," a humorous piece on life there during wartime.

1943 Marries Dolly Haas, a German film star. Writes in "Main Street Hollywood": "The true Hollywoodian is integral with his surroundings. He reflects in a wonderful way the strange life and the blown up values in the make-believe world he has invented and elaborated."

1945 To commemorate the birth of his daughter Nina, he hides her name in a drawing for the New York Times.

1947 For first installment in Holiday magazine series he illustrates S. J. Perelman's caustic take on Hollywood, "the Athens of the West, the mighty citadel which had given the world the double feature, the duplexburger, the motel, and the Hamfurter." The pieces are collected into the best-seller, Westward Ha! (Or Around the World in 80 Clichés).

1948 Starts two-year series of film portraits for Seventeen magazine.

1949 Authors illustrated article on "Hollywood Types" for Holiday magazine.

1952 Begins to illustrate a weekly column by John O'Hara for Collier's that frequently includes portraits of film personalities.

1954 Creates mural of seventy-five film stars for the Fifth Avenue Cinema in New York. Original drawing is acquired by the Whitney Museum of American Art in 1960.

1956 Begins twenty-year association with United Artists, providing publicity drawings for newspapers and magazines around the country.

1965 The New York Times commissions first drawing of a film, Ship of Fools.

1968 Produces a record thirty-nine drawings of the film Star! (starring Julie Andrews) for publicity purposes.

1977 IBM commissions forty-eight drawings of Hollywood classics for a nationwide newspaper campaign. Another forty-eight are commissioned in 1979.

1982 For the Limited Edition Book Club, he illustrates A Streetcar Named Desire, using the film as visual reference rather than the original stage production.

1991 "Comedians by Hirschfeld" postage stamps issued by the United States Post Office, featuring portraits of Laurel and Hardy, Abbott and Costello, Fanny Brice, Jack Benny, and Charlie McCarthy and Edgar Bergen.

1992 Creates his last poster art of the twentieth century for the film adaptation of Noises Off.

1994 "Stars of the Silent Screen," a set of ten postage stamps drawn by Hirschfeld, issued by the United States Post Office. Drawing of the Dreamworks founding triumvirate reproduced on the front page of the New York Times. Disney bases Genie in Aladdin animated film on Hirschfeld drawings.

1996 Susan Dryfoos's Academy Award–nominated documentary on Hirschfeld, The Line King, is released.

1998 Includes Spielberg and Chaplin in cover art of "Artists of the 20th Century" for Time magazine.

2000 Disney pays homage by basing the "Rhapsody in Blue" segment of Fantasia 2000 completely on Hirschfeld's style of drawing.

2001 Draws Oscar nominees for the New York Times.

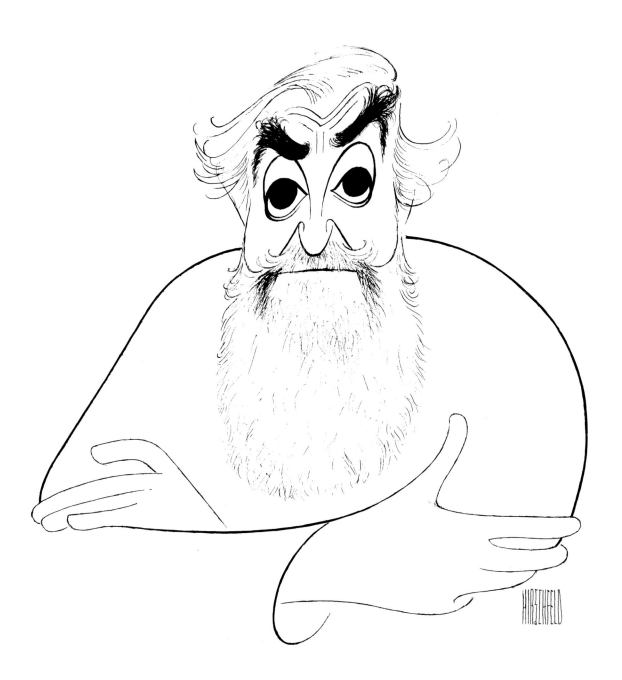

Self-portrait. Pen and ink on board, 1985.
Melvin R. Seiden Collection, The Harvard Theatre Collection, The Houghton Library

Index

Editor: Elisa Urbanelli
Designer: Ellen Nygaard Ford

Library of Congress Cataloging-in-Publication Data

Leopold, David.
 Hirschfeld's Hollywood : the film art of Al Hirschfeld / text by
David Leopold ; foreword by Larry Gelbart.
 p. cm.
 ISBN 0-8109-9052-0
1. Hirschfeld, Al. 2. Motion pictures—Caricatures and cartoons.
3. American wit and humor, Pictorial. I. Title.
 NC1429.H527 A4 2001a
 741.5'092—dc21
 2001002312

Printed and bound in Hong Kong
10 9 8 7 6 5 4 3 2

Al Hirschfeld is represented by the Margo Feiden Galleries Ltd., New York

The Academy would like to thank Judith Singer, Warner Bros.
legal department

page 1: **Oscar—Angel or Devil?** Pen and ink on board, 1988.
Collection Academy of Motion Picture Arts and Sciences.
Oscar statuette ©AMPAS®
page 2: **Hirschfeld painting a mural of Jimmy Durante**

Harry N. Abrams, Inc.
100 Fifth Avenue
New York, N.Y. 10011
www.abramsbooks.com